Making Connections

Interdisciplinary Art Activities

Barbara Mickelsen Ervin

J. WESTON

WALCH

PUBLISHER

Portland, Maine

User's Guide
to
Walch Reproducible Books

As part of our general effort to provide educational materials which are as practical and economical as possible, we have designated this publication a "reproducible book." The designation means that purchase of the book includes purchase of the right to limited reproduction of all pages on which this symbol appears:

Here is the basic Walch policy: We grant to individual purchasers of this book the right to make sufficient copies of reproducible pages for use by all students of a single teacher. This permission is limited to a single teacher, and does not apply to entire schools or school systems, so institutions purchasing the book should pass the permission on to a single teacher. Copying of the book or its parts for resale is prohibited.

Any questions regarding this policy or requests to purchase further reproduction rights should be addressed to:

Permissions Editor
J. Weston Walch, Publisher
321 Valley Street • P. O. Box 658
Portland, Maine 04104-0658

1 2 3 4 5 6 7 8 9 10
ISBN 0-8251-3733-0

Contents

To the Teacher

The Purpose of Interdisciplinary Activities

No area of study can function effectively in isolation. Everything is related in some way. The purpose of interdisciplinary activities in the classroom is to create a more natural and understandable view of society as a whole. Art is a mirror that reflects the intellectual and emotional echoes of humankind. With very little effort, almost any subject can be related to art. This book attempts to simplify art activities for use in conjunction with other subjects as well as art for art's sake. It encourages the application of art to enrich all areas of study.

Philosophy

From the first significant art recorded on cave walls to the computer-generated images of today's world, the visual arts are an essential part of humankind. Students need to learn how to process the ever-growing quantities of visual images that bombard society. We should look at visual arts education as a way of preparing our students to be able to process this information. In order to begin to understand the visual arts as a whole, they must first understand how the arts relate to every aspect of our world of learning. To achieve this, we must involve every discipline within a well-rounded curriculum.

Our leisure-time technology and our natural craving for conformity have molded us into a society of watchers and viewers rather than of doers. We ask to be entertained and repeat well-polished logical ideas.[1] From kindergarten to college, we are taught to take in information, and are expected to give back the same information in the same form. As a whole, our standard educational methods leave little or no room for open-ended creativity. This is what art offers—a chance to experiment without failure. Art encourages open-minded curiosity and exploration. It gives us a chance to accept or reject a simple plan of action, to achieve a successful result as stated in a student's own objective.

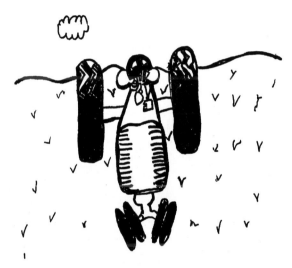

1.1 *Tractor* by Michael, age 11

When a child first starts to explore the world (an open-ended type of activity) any cause-and-effect relationship is exciting and is repeated over and over—but never in the same way.[2] The excitement of making a mark or pasting a shape is pure exploration and is not intended, or expected, to be anything concrete. "Genuinely creative thinking in any field is done on an abstract level unlimited by practical considerations. The teaching of art must try to evoke an appreciation of things in

their own right."[3] The result is a common objective that is formed in a way that is unique and personal.

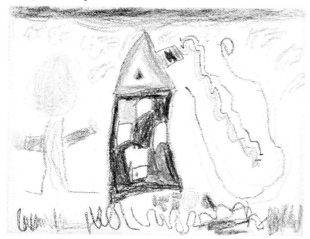

1.2 *My House* by Graham, age 4

To compare the two illustrations titled "My House," note the similarities between the format of each house and environment. Graham gives a fanciful portrayal of her house using the basic symbols of an earlier stage of artistic development. During the preadolescent stage of development, there is an attempt to explore realism and detail. Note Jesse's attempt at drawing the roof in perspective.

The classroom teacher is, in most cases, expected to be master of all activities required in the classroom. As we know, this is nearly impossible. Subjects such as art, music, and physical education are taught by specialists. These teachers are able to teach "open-ended" creativity to children, who can learn that they can flow freely within the structural guidelines provided—and that the unexpected and unplanned is accepted and a part of the process.

The classroom teacher can have the chance to create such a stimulating environment only by showing enthusiasm and a fearless determination to provide these high-success activities in all subjects. Photocopy, stencil, and general copy work all have their place in the classroom (they promote fine motor skills, organization, and rote memory skills), but overuse can make them ineffective

and dull. Classroom activities that offer students precut, pre-colored, and pre-designed artwork for the sake of achieving

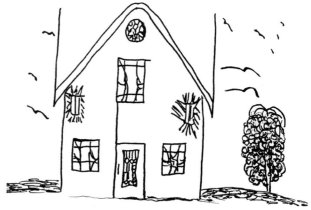

1.3 *My House* by Jesse, age 10

an adult standard of beauty or order leave students with little (aside from pasting) to call their own.

Effective teachers use a variety of activities and materials. A good classroom teacher not only supplements the activities of the specialists but follows up and works with students to intensify the whole experience of creative thought. Through these types of activities, children nurture this sensitivity to their surroundings and their world in general. To look at an object, to question, and see beyond the obvious, to see the colors, the shapes, the reason for its existence with other elements of the whole—this is what an art-based curriculum teaches. It brings out the creator in all of us! It teaches us to create not for the product only, but for the experience. Good experiences create a sensitive, better-adjusted society in which to live.

Motivation

Children are naturally filled with a desire to learn and are highly motivated by their own interests. The adage "I see. I do. I understand." is never so true as with younger children. It is important for children to feel

that their efforts have importance to peers and adults. "A child must feel accepted and secure before he [sic] chooses to explore and create."[4] In order to secure this feeling, a teacher must provide an opportunity for positive evaluation.

A classroom filled with displays of student efforts is very effective and signifies sincere approval from the teacher. The best way to encourage growth of self-esteem is through success—through focusing on the process rather than the product. The development of these positive growth experiences should begin early in childhood and continue throughout life.

Evaluating Artwork

The criterion for evaluation is not whether a work is "good" or "bad." Student creations are individual expressions on which impersonal judgments cannot be made. Instead, ask if the student participated wholeheartedly in the activity. Were directions followed? Was neatness a consideration? Were open-ended situations dealt with creatively? Something positive should be found in every child's artwork.

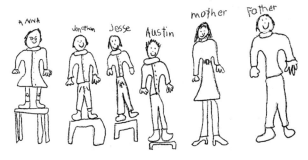

1.4 *My Family* by Jonathan, age 10

Jonathan has created a family portrait in which everyone is equal in height rather than graduating in size or importance. The problem of difference in height has been solved by the platforms on which the children stand. He has been very attentive to details of each individual's attire. This possibly shows equality yet individuality within the family.

The Middle School Child

Dr. Benjamin Spock, the well-known author and authority on child-rearing, states in his best-selling book *Baby and Child Care* that "the main lesson in school is how to get along in the world."[5] This seems to be the primary struggle for the age group we call the middle school age. At this stage of development, anything can happen! Because of the unstable nature of this age group, students may turn to copying or tracing to produce a "good" piece of artwork. In his book *Creative and Mental Growth*, Victor Lowenfeld calls this age the "Gang Stage." Suddenly, the opinion of peers becomes very important because it seems to confirm a child's special place in the world.[6] Girls begin to churn out tried-and-true subjects such as rainbows and flowers, while boys turn to an army of airplanes and superheroes because they are easy successes and are appealing. Use of shadow and depiction of emotions may be among the attempts to create realism in artworks by this age group. Colors are not as bright, and tints and shades as well as naturalistic textures may be attempted. There is less exaggeration in the figures than in the earlier stages of art development, and the artist is many times represented among the situations drawn.

Characteristics of the Preadolescent or Realistic Stage, 9–14 years	
• The sky meets the ground. • The student becomes self-critical and socially conscious. • The student becomes more cautious. • Preferred subject matter differs for girls and boys. • Pictures are more complete. • Drawings strive for realism.	• There is understanding of linear perspective. • Colors include tints and shades. • There is less exaggeration in figures. • Distant objects become smaller and lighter. • Background gets more attention. • Objects begin to overlap.

The artist belonging to this age group can benefit from classroom critiques, provided the criticism is conducted in a very positive manner. This stage is the most fragile in that it can "make or break" a child's like or dislike for art. The teacher can help the 9- to 14-year-old grow by praising the person instead of only the product. Also, a teacher can encourage individuality with the use of abstract and open-ended projects rather than primarily realistic designs. Techniques in the basic design skills (such as creating illusion with light, shadow, and line as in drawing in perspective) are often picked up easily by this age group. Once these skills are grasped, they become high successes in the struggle for artistic confidence.

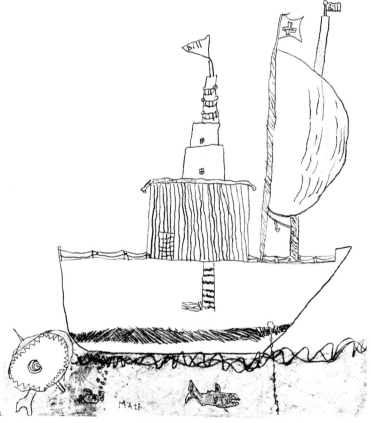

1.5 *Bill's Boat and the Great White Shark* by Matt, age 9

In this illustration, Matt shows an attempt at realism in the billowing sails of the ship and the frontal view (looking down into the throat) of the shark behind the boat.

Suggestions for Teaching Exceptional Children

The unique differences of each exceptional child make creating set approaches to a suitable teaching strategy difficult. The activities in this book offer insights into various aspects of programming but, *you*, the teacher, are responsible for making the decisions as to which activities are suitable to meet the special needs of your students. "With adaptations and special methods, all children can be included in everything."[7] Most activities described in this book can be modified to meet those needs with just a few changes. (See the "Special Tips" sections in the teacher material.) These activities encourage open-ended process rather than product-oriented opportunity for the exceptional child. Teachers need to be sensitive to the readiness level of the student, as well as each student's level of psychomotor or physical abilities.

To accommodate each individual, stress some procedures and minimize others without deviating from particular objectives.[8] No matter what the age of the exceptional artist, whether 52 or 12, the artwork has an honest, joyful appeal to it. Many times such artists see things from a unique perspective.

Gifted Children

Gifted children would benefit from activities that challenge and stimulate on a level higher than grade level. Offer such children problems of design or open-ended techniques needing solutions—problem-solving done on an abstract level. Gifted children are more apt to be "risk takers," that is, they tend to see problems as having solutions. These young artists see adding detail as sheer fun, improvising as the image unfolds in storylike form. This allows them to work in depth with intriguing concepts, to create choices and multiple solutions, gaining insight into the problem as a whole.[9]

In these illustrations, Maghan and Michael use their exceptional artistic skills to draw subjects typical of this age group.

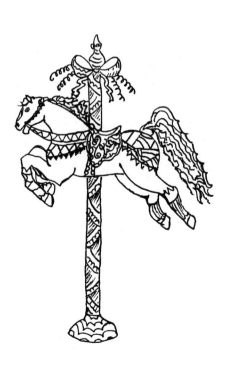

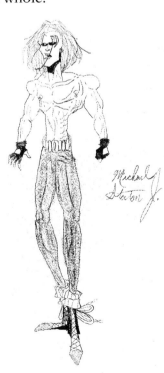

1.6 *The Carousel* by Maghan, age 11

1.7 *Man* by Michael, age 12

Children with Attention Deficit Disorder

One characteristic of children with attention deficit disorder (ADD) is that they are highly creative.[10] Artistic endeavors become a wonderful outlet for them to express their feelings and views of the world. These children should be given guidelines to work within but should not be bound too tightly to them. The objective will usually be met but not always in a conventional way. Observe this and appreciate the fact that they are using an outlet such as art to express themselves in an open-ended way. Like scattered rays of sunlight focused through a magnifying glass, many children are incredibly focused when creating something uniquely their own. This should prove to be a good mental exercise for those children who have trouble staying focused on a task.

Children who show these exceptionally creative tendencies seem to have an interest in a number of areas of study. They may excel in visual artistic endeavors as well as other areas such as music, science, or literature. These children constantly search for new ways of expressing themselves and are right at home with the challenge of the concept of multiple solutions.

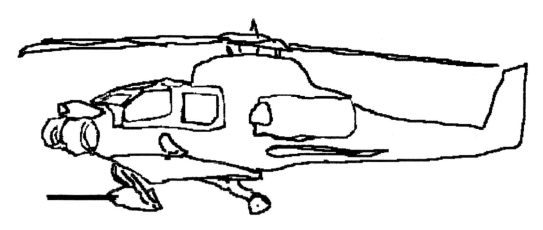

1.8 *Chopper* by Daniel, age 10

Daniel is a very gifted yet distractible young man. His usual attention deficit behavior was harnessed when he focused on the creation of this artwork. Daniel drew this helicopter using a mouse on a computer.

Hearing-Impaired Children

To instruct children with impaired hearing, it may be helpful to try demonstrations instead of lectures. Pantomime techniques are helpful in showing concepts. These children depend on their visual perception to receive communication. Exploit the acute perceptiveness of these children, challenging them to develop a method of responding with visual media.

Speech-Impaired Children

For children with speech problems, art can provide a way to communicate without words. Speech problems are often linked with impairment of hearing. Use like methods of teaching. You may want to emphasize content rather than form so that the children can communicate those things they want to "say."

Motor-Handicapped Children

Children with motor handicaps often cannot manipulate the small instruments used in most art activities. Since this may cause difficulties in creating representational images, emphasize shapes, colors, and designs over subject matter. You may also find it helpful to encourage manipulative activities such as modeling or construction for children with motor difficulties.

In cases of severe motor or visual impairment, you may transmit movements directly to the child's hands by placing your hands on his or hers while the child performs the activity. The child learns the motor skill without having to translate a visual image into a movement. This technique works well with mentally-handicapped children as well.

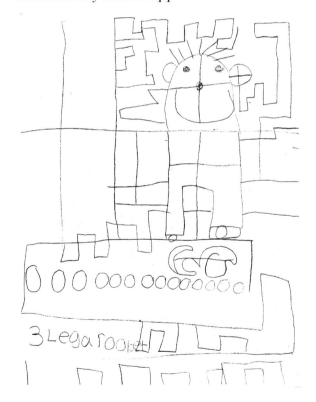

1.9 *The Three-Legged Robot* by Kevin, age 11
Kevin is a middle school special-education student with Down's syndrome. His design has a careful, ordered rhythm, showing that his fine motor skills are improving.

Emotionally-Handicapped Children

Emotionally-handicapped children benefit from using representational subject matter. An art experience can heal children because it can portray unfulfilled wishes and unacceptable feelings in an acceptable way. Many times the "edge" can be taken away from a recent frustration or experience by drawing the experience in story form or sequence. By transferring these images to another plane, students have absolved themselves of the intimate nature of the experience. This technique also applies to good experiences. Many times it is hard to channel the excitement created by a big event or a great experience except by transferring it into another form. By providing acceptance and reassurance you build the secure atmosphere that this requires.

Emotionally-handicapped and hyperactive children benefit from quick success. Media that produce fast results attract the children's interest and prolong their attention. Marble art, for example, produces instantaneous images. Similar projects prevent unnecessary stress and provide graphic reinforcement for the child's creative endeavors.

Educable Mentally-Handicapped Children

Although educable mentally-handicapped children are more capable than trainable children, they seem to have difficulty with conceptual abstractions. You may find it helpful to concentrate on creating items with obvious uses. These children may benefit from representational art. You may find it beneficial to methodically demonstrate each step of an activity, leaving nothing to intuition.

1.10 *Untitled* by Rashun, age 12

In his special-education classroom and at home, Rashun draws pictures at any chance. He will begin one design and then create the crosslike symbols across the paper in a very rhythmic manner. Even though his other fine motor skills have progressed, as shown in his handwriting, he has been producing this same drawing behavior for several years.

Trainable Mentally-Handicapped Children

Trainable mentally-handicapped children could benefit from a concentrated study of practical design applications. You might have the children create useful art such as directional signs. These children benefit from exercises that use repetition. They have a natural tendency to repeat symbols. This gives their work a particularly rhythmic quality. All activities with these children must have very simple, closely supervised procedures. Concentrate on developing motor skills and simple concepts.

Learning-Disabled Children

You may find it helpful to emphasize developmental concepts of space, sequential order, and grouping for children with learning disabilities. Painting, clay modeling, or pattern drawing may develop sequential ordering. In drawing from imagination to combine or associate ideas with tactile materials, these students are developing concepts and overcoming their learning problems.

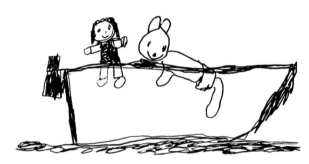

1.11 *Sophie and Me at the Lake* by Dianne, age 52

Dianne is a very happy and creative 52-year-old who is mentally handicapped. She loves to draw and swim, as seen in this picture, created at a lakeside with a dog in the boat. Her mental and physical abilities are comparable to those of the middle school special-education students mentioned in this text. Even though we tend to think the physical and mental handicaps would frustrate the artistic development of special students, the piece is joyously executed as an alternate means of sincere expression.

1.12 *Drawing by Michael, age 12*

The Art Class

Using art activities in the classroom can be very successful if a few suggestions are followed:

Encourage a creative climate in the classroom.

A certain amount of constructive conversation and purposeful moving about can boost creativity and encourage independent thinking. "Permissiveness" (not mayhem) implies that classroom order is flexible, not abandoned. Experimentation and exploration are encouraged.

The condition of materials—before and after use—is the responsibility of every student. Students should show consideration of others.

Plan far enough in advance to have adequate materials on hand.

To obtain materials:

- Check what is available from your school supply room.

- Save materials from home such as egg cartons and newspapers.

- Send a note home to parents asking for the materials you need, not only for day-to-day use but for special projects. Parents are usually helpful in providing materials for the classrooms.

- Ask local businesses or individuals for excess materials or "throwaways."

- Buy materials yourself. Many art supplies are inexpensive but are invaluable for expanding art activities.

Work with the art specialist when one is available.

Working with art in your classroom expands the range of new experiences for your students. Working with the art specialist on follow-up and mutual activities can enrich your curriculum.

Avoid passing off pattern tracing, copy work, and stereotyped techniques as art activities.

Encourage each child to trust his or her own way of thinking. Invite self-expression. Remember that *there is no right or wrong way to be creative.*

Hold a positive view of every child's efforts.

Children in this age group seem tough but are really very sensitive and need praise.

Display the artwork prominently with pride.

Children sense reactions to their efforts. A display not only boosts self-esteem but creates a pleasant and artistic atmosphere for everyone who comes into contact with the art projects.

Do not be afraid to make a mess!

As in anything that is totally involving, at times, the rules have to be broken. But . . . order has its place even in the most creative atmosphere. Be alert to wasteful activities and intentionally messy art. All children should be responsible for the condition of supplies during use and cleanup. As the children clean their own areas, it is helpful to have a small committee of students take up tools and materials and carry the wastebasket to each desk to collect trash.

Add what you know to any art project.

Anything can be changed to fit the classroom situation. You are as creative as anyone, and only you know what will relate to your classroom situation.

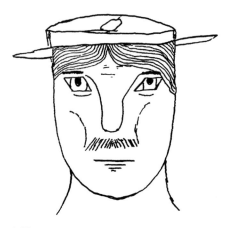

1.13 *A Man with a Hat* by Austin, age 13

Notes

1. W.F. Wankelman, *A Handbook of Arts and Crafts*, p. 2.

2. F. Caplan, *The First Twelve Months of Life*, p. 173.

3. W.F. Wankelman, *A Handbook of Arts and Crafts*, p. 2.

4. F. Caplan, *The First Twelve Months of Life*, p. 174.

5. Dr. Benjamin Spock, *Baby and Child Care*, p. 442.

6. Victor Lowenfeld, *Creative and Mental Growth*, pp. 182–183.

7. *Insights: Art in Special Education—Educating the Handicapped Through Art*, p. 55.

8. A. Hurwitz, *The Gifted and Talented in Art*, p. 72.

9. A. Hurwitz, *The Gifted and Talented in Art*.

10. Bonnie Carmond, *The Coincidence of Attention Deficit Hyperactivity Disorder and Creativity*, pp. 1–3.

Bibliography

Alkema, Chester J. *Art for the Exceptional.* Boulder, CO: Pruett, 1971.

Art Activities from Around the World. Wilkinsburg, PA: Hayes School Publishing, 1982.

Artfully Easy. New York: Instructor Books, 1983.

Basic Art Skills. The South Carolina Framework for Visual Arts Education, South Carolina Department of Education, 1989.

Blackburn, Ken. *The Paper Airplane Book.* New York: Workman, 1994.

Burnie, David. *How Nature Works.* A Reader's Digest Book. London: Dorling Kindersly Ltd., 1991.

Caplan, F. *The First Twelve Months of Life.* New York: Bantam, 1973.

Carmond, Bonnie. *The Coincidence of Attention Deficit Hyperactivity Disorder and Creativity.* National Research Center for the Gifted and Talented, 1995.

Elementary School Art Curriculum Guide. Greenville, SC: School District of Greenville County, 1980.

Girl Scout Handbook. New York: Girl Scouts of the U.S.A., 1986.

Grolier Multimedia Encyclopedia. Danbury, CT: Grolier Electronic Publishing, 1996.

Hann, Judith. *How Science Works.* A Reader's Digest Book. London: Dorling Kindersly Ltd., 1991.

Hart, George. *Ancient Egypt.* Eyewitness Books. New York: Alfred A. Knopf, 1990.

Hurwitz, A. *The Gifted and Talented in Art: A Guide to Program Planning.* Worcester, MA: Davis, 1983.

Insights: Art in Special Education—Educating the Handicapped Through Art. Millburn, NJ: Art Educators of New Jersey, 1976.

Kellogg, R., and S. O'Dell. *The Psychology of Children's Art.* New York: Random House, 1967.

Lowenfeld, V., and W. L. Brittain. *Creative and Mental Growth.* New York: Macmillan Publishing Co., 1975.

Park, L. *Craft Attack*. Sydney: Ashton Scholastic, 1990.

Peel, Kathy A. *A Mother's Manual for Summer Survival*. Pomona, CA: Focus on the Family, 1989.

Pellant, Chris. *Rocks and Minerals*. Eyewitness Books. London: Dorling Kindersly Ltd., 1992.

Reid, William, Jr. *Great Craft Projects from Around the World*. Portland, ME: J. Weston Walch, Publisher, 1999.

Rodriguez, Susan. *Art Smart*. Englewood Cliffs, NJ: Prentice-Hall, 1988.

Spock, Benjamin. *Baby and Child Care*. New York: Pocket Books, 1968.

Terzian, Alexandra M. *The Kids' Multicultural Art Book: Art and Craft Experiences from Around the World*. Charlotte, VT: Williamson, 1993.

Volpe, Nancee Olsen. *Seasonal Arts and Crafts*. Carthage, IL: Good Apple, 1982.

Wankelman, W. F., and P. Wigg. *A Handbook of Arts and Crafts*. Dubuque, IA: Wm. C. Brown Publishers, 1989.

Many activities were contributed by the Art 301, Art for Teachers Class, Erskine College, South Carolina from 1986–1996.

Thank you to the following for the use of their artwork: 1.1, Michael McCall, 1.2, Graham Ervin; 1.3, Jesse Langston; 1.4, Jonathan Langston; 1.5, Matthew Ervin; 1.6, Maghan Lusk; 1.7, Michael Staton; 1.8, Daniel Strawhorn; 1.9, Kevin LeCroy; 1.10, Rashun Pitts; 1.11, Dianne Bishop; 1.12, Michael Staton, 1.13, Austin Langston.

Making Connections: Subject Area Correlation

This grid shows some of the many interdisciplinary connections that can be made using these activities. Teacher notes on individual activities suggest themes for using the activities in different subject areas.

	Math	Science	Language Arts	Social Studies	Art or Music
Making Paper		X		X	X
Illuminated Bookmark			X	X	X
Hole Punch Picture				X	X
Paper Quilt Design	X			X	X
Tangram	X			X	X
Chain of Hearts				X	X
Mola				X	X
Positive-Negative Design			X		X
Op Art		X		X	X
Stained Glass	X			X	X
Sketching Ideas			X		X
Contour Line Drawing			X		X
Perspective		X			X
Stargazing	X	X	X	X	X
Cartoons			X		X
Texture		X	X		X
Bookbinding			X	X	X
Eggshell Mosaic	X	X	X	X	X
Powdered Dye Sprinkle Painting		X			X
Pulled String Design		X			X
Bubble Doubles	X	X			X
Bleach Painting		X			X
Squeegee Painting		X			X
Sponge Painting		X			X
Splatter Painting		X			X
Blottos		X	X		X
Marbleized Paper		X	X	X	X
Tissue Paper Tie-Dye				X	X
Crayon Batik				X	X
Crayon Engraving			X	X	X
Crayon Shaving Cards			X	X	X
Snowflake Resist		X		X	X
Sand-Painted Postcards		X		X	X
Leaf Printing		X			X
Vegetable Printing		X		X	X
Fish Printing		X		X	X
Plastic Foam Printing		X	X	X	X

	Math	Science	Language Arts	Social Studies	Art or Music
Pyramids and Polyhedrons	X	X		X	X
Paper Cup	X		X	X	X
Mobius Magic	X			X	X
Spiral Breeze Catcher	X	X			X
Pinwheel		X		X	X
Twirling Glider		X		X	X
Vortex		X		X	X
Screamer		X			X
Twirling Colored Disks		X		X	X
Spinning Top		X		X	X
Jellyfish		X			X
Ocean in a Jar		X			X
Cartesian Diver		X	X		X
Glass Bottle Barometer	X	X	X		
Palm Tree		X		X	X
Stand-up Tree		X		X	X
Japanese Fan		X		X	X
Paper Mask	X			X	X
Marshmallow and Toothpick Ornament	X	X		X	X
Chinese New Year Mask		X		X	X
Treasure Pouch	X		X	X	X
Ojos de Dios				X	X
Board Weaving with Yarn	X			X	X
Natural Dye Eggs		X		X	X
Geodesic Shapes	X			X	X
Creepy Crawly Critters		X	X		X
Indian Corn		X		X	
Dreidel		X		X	X
Kazoo		X			X
Rhythm Shaker					X
Not-So-French Horn		X			X
Shoebox Banjo		X			X
Panpipes	X			X	X
Maraca				X	X
South American Rain Stick		X		X	X

Paper Activities

Paper Techniques (p. 7) _____

These techniques for working with paper can be used for many of the activities in this book.

Objectives

Students will:

- learn to manipulate paper by cutting, folding, tearing, bending, and scoring
- learn to create two- and three-dimensional forms from paper
- discover the versatility of paper

Special Tips

- Special needs students may find that tearing a design may be easier than trying to manipulate a pair of scissors. Also, having you *score* the design before they try to cut or tear will make for a better result.

Making Paper (p. 8) _____

Themes

- Science: studying various aspects of the papermaking industry, the properties of different pulps
- Social studies: recycling, Oriental cultures, early American life
- Art: papermaking/fiber arts

Objectives

Students will:

- become aware of the recycling process
- explore the process of simple papermaking

Preparation

- If you wish to use the mold and deckle method, use the staple gun to staple the screen cloth to one of the 5" × 7" wooden frames. This is the *mold*. To use the second frame as a *deckle*—which helps give the paper an unusual edge—just place the empty second frame over the screened first frame before inserting the frames into the paper pulp.
- You can prepare the pulp in advance by doing steps 1 and 2 outside the classroom.

Illuminated Bookmark (p. 10) _____

Themes

- Social studies: the medieval period
- Language arts: any piece of literature being studied: specify that the bookmark should reflect the literary work.
- Art: calligraphy

Objectives

Students will:

- examine an art form from the medieval period
- experiment with the art of illumination
- create a usable piece of art

Special Tips

- Students who find the vertical concept too abstract may be more successful with the horizontal format.
- To avoid frustration when students with poor motor skills try to execute

lettering, use stencils to outline the letters for students.

- For students with special needs, crayons may be easier to manipulate than markers or pencils, but if crayons are used, don't use a heat laminator for the finished bookmark.

Hole Punch Picture *(p. 11)*_____

Theme

- Social studies: early American crafts and decorative arts
- Art: decorative arts

Objectives

Students will:

- learn to achieve a textured effect by punching holes
- develop visual discrimination skills

Preparation

- Each student will need a piece of cardboard, construction paper, and nails.

Special Tip

- Special needs students who can hold a pencil should have no difficulty with this activity. Closely supervise students for placement of the cardboard and the punch.

Paper Quilt Design *(p. 12)* _____

The use of primary colors for the background and secondary colors for the quilt pieces is to teach these color groups. Any selection of colors may be used.

Bring in an actual quilt, if possible. Point out to students the geometric shapes, if any, and the patterns used in the design.

Themes

- Social studies: early American crafts and decorative arts
- Math: geometric shapes
- Art: early American crafts/pattern

Objectives

Students will:

- learn to identify geometric shapes
- learn to develop patterns
- gain an understanding of folk art

Preparation

- Ahead of class, make enough tagboard geometric shapes for the whole class. Alternatively, provide stencils of the shapes for students to trace onto the secondary paper.
- To make a collage quilt, cut out shapes from magazines or newspapers for students to use instead of geometric shapes. You may wish to choose a theme such as flowers or familiar symbols.

Special Tips

- Provide precut pieces for special needs students having a hard time cutting small pieces.
- Keep the design very simple for special needs students who have difficulty following and replicating a pattern. Try providing an outlined area for them to paste in.

Tangrams *(p. 13)* _____

Themes

- Math: geometric shapes
- Social studies: Chinese culture, early American crafts
- Art: creative visual concepts, patterns

Objectives

Students will:

- gain understanding of geometric shapes
- create a recognizable design from geometric shapes

Preparation

- Make enough copies of the tangram masters for the whole class.

Special Tip

- Special needs students may find this activity good for developing spatial relationships in pattern and design. This activity may be too abstract for some, however. Point them to the illustrations for examples.

Chain of Hearts (p. 15) _____

Themes

- Social studies/Holiday: Valentine's Day
- Art: seasonal activity

Objectives

Students will:

- understand the concept of proportion
- develop fine motor skills through cutting

Special Tip

- If special needs students are having difficulty with this activity, prefold the paper and predraw the succession of heart sizes.

Mola (p. 16) _____

Themes

- Social studies: Central American art
- Art: abstract designs, color mixing

Objectives

Students will:

- develop fine motor skills
- mix and match colors
- learn about Central American art

Special Tip

- Special needs students may have conceptual difficulties with this activity. Try pairing them with other students.

Positive-Negative Design (p. 17) ___

Theme

- Language arts
- Art: basic design/color and theory

Objectives

Students will:

- explore positive and negative emotions
- create simple positive-negative designs

Preparation

- Cut full-sized construction paper sheets of various colors into the smaller sizes called for.

Special Tip

- Special needs students may benefit more from simply discussing the way certain colors and shapes make them feel than from carrying out the entire activity.

Op Art (p. 19) _____

Themes

- Social studies: 1960's culture
- Science: optical illusions
- Art: complementary colors

Objectives

Students will:

- learn complementary colors
- cut and paste in an orderly design
- learn to understand a contemporary art form

Special Tips

- Special needs students may find the cutting and rhythmic placement of the strips of paper difficult. An alternative may be to have a simple predrawn design for them to color alternate spaces in complementary colors.
- Students may need help choosing complementary colors.

Stained Glass (p. 20) _____

Themes

- Social studies: religious symbolism, religious buildings, medieval era
- Art: architecture
- Math: geometry

Objectives

Students will:

- create mock stained-glass designs by cutting and pasting
- attempt to coordinate several colors into a design

Special Tip

- Special needs students may have difficulty cutting the design. Try having them glue foiled wrapping papers, precut into various shapes, to heavily outlined areas predrawn on the black construction paper.
- Students with underdeveloped fine motor skills may find a glue stick easier to use than regular glue.

Sketching Ideas (p. 21) _____

Themes

- Language arts: creative writing
- Art
- Music

Objectives

Students will:

- learn to sketch
- learn to draw four to eight sequential ideas for a picture

Preparation

- Ahead of time, choose a few brief stories to read to the class, or play a brief programmatic piece of instrumental music and have students sketch what they think is happening in the music. After everyone is finished, tell the class what the composer intended the music to be about. Invite students to tell the class about their sketches.

Contour Line Drawing (p. 22) _____

Theme

- Language arts: creative writing
- Art: drawing with one line

Objectives

Students will:

- experience drawing with one line
- visualize an object through touch
- learn that contours show the important edges of an object

Preparation

- Fill a bag or sack with interesting small objects.

Special Tip:

- Special needs students may find this activity difficult. Try giving them WikkiStix (tacky waxed cords) to create outline "drawings" of objects.

Perspective (p. 23)_____

Bring in examples of artworks from both before and after the discovery of perspective.

Themes

- Art: lettering
- Science: optical illusions

Objectives

Students will:

- understand the illusion of depth in perspective drawing
- learn to write in block letters

Stargazing (p. 24) _____

You may wish to read a Greek constellation myth to the students. Or, bring in a star chart and have them try to locate and trace constellations based on the pictures (often superimposed) they represent.

Themes

- Social studies: Greek mythology
- Science: astronomy, constellations; optical illusions
- Math: geometry
- Language arts: creative writing
- Art: optical illusions in design

Objectives

Students will:

- create a star design using points on a graph

- develop their understanding of the history of astronomy

Special Tip

- Special needs students may find steps 1 and 2 of the extension activity easier as a prepared connect-the-dots activity.

Cartoons (p. 25) _____

Themes

- Language arts: plot, comic book illustration, punch line
- Art: commercial illustration

Objectives

Students will:

- understand facial expressions
- create simple drawings in cartoon style
- create an original cartoon strip

Special Tip

- Special needs students may find this activity exciting if a circle is drawn around the eye/mouth figures to make a face. The comic strip may be particularly challenging.

Texture (p. 26) _____

Themes

- Science: the senses
- Language arts: Braille
- Art: texture rubbings

Objectives

Students will:

- discover tactile textures in a visual way
- discover many different surfaces
- use areas of texture in a drawing

Special Tip

- Special needs students may find this a good project for developing fine motor skills through the action of rubbing crayons onto paper laid onto a surface. Have the students touch surfaces first with their eyes closed and then with them open. Talk about the differences.

Bookbinding (p. 27)

Themes

- History: printing technology
- Art: illustration and book design, sketching
- Language arts: creative writing

Objectives

Students will:

- create an original book for personal use
- develop an understanding of the history of the book

Special Tip

- This activity may be easier for special needs students if they are provided with paper to staple together and glue into a cover. They may want to create a color book or a shape book or put on the pages anything they are studying at the time.

Eggshell Mosaic (p. 28)

Themes

- Science: reptiles
- Art: Greek and Roman art
- Social studies: ancient Greek and Roman art and architecture
- Math: geometric designs in reptiles' coloring
- Language arts: mythology

Objectives

Students will:

- gain skill in manipulating and joining material to create a real or imagined creature
- use alternative materials to create texture

Preparation

- For the week leading up to this activity, collect (and ask students to collect) clean, dry eggshells.

Special Tip

- Special needs students may find this activity difficult owing to the fine motor skills required. Try using construction paper instead of eggshells. Tear the paper into irregularly-shaped pieces that are large enough for your students to handle easily—perhaps around an inch in diameter. Pre-draw a lizard or other creature on tagboard, then have students attach the paper "scales" with a glue stick.

Paper Techniques

To **curl**, draw paper between thumb and an edge of a pair of scissors or a sharp-edged object. Paper can also be curled by rolling on a pencil in a straight or spiral manner.

To **fringe**, make multiple cuts along the paper's edge. These can be curled for a fluffy effect.

Cut to the center to make a **spiral**.

To **score**, use a dull point such as the back of a scissors blade and impress along any line that is to become a fold. This produces a crisp fold. Do not tear the paper by pressing too hard.

To **slash**, cut a slit in a piece of paper. If interlocking, insert the end of another piece cut in the same manner. Pull through to desired position and glue. Control the size of the slits and inserts for desired effects.

Curling

Scoring

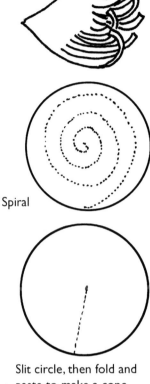

Fringing

Spiral

Slit circle, then fold and paste to make a cone.

Tube with tabs

Slit shapes, then interlock

Cut three strips and braid

Paper spring

Name _____ Date _____

Making Paper

Creating paper material from plant fibers is a relatively old process. It was first developed in China many centuries ago.

What would our lives be without paper? The uses for paper are too many to count. Many exhibits of colonial American life show the process of papermaking, as this was one of the important skills the colonists brought to America with them.

Materials

Washpan (about 6" deep)

Blender

Scraps of paper (newspaper or construction paper works well)

Window screen (5" × 7")

Scissors

Felt *or* wool blankets *or* old towels

Newspaper for blotting wet paper

Sponge

Optional: one or two 5" × 7" wooden frames to use as mold and deckle, staple gun

Procedure

1. Shred or cut the scraps of paper into small pieces. Let them soak in water overnight.

2. Put the paper scraps and water in a blender, about $\frac{1}{3}$ cup paper to $\frac{2}{3}$ cup water. Blend the paper and water together.

3. Place a piece of damp felt on a pile of newspapers near your work area.

4. Fill a washpan about three-quarters full with water. Pour the pulp mixture into the water in the pan. Use your hands to mix the pulp and water together.

5. Dip the screen under the surface of the water so that it is parallel to the surface. Then lift the screen carefully up out of the basin, keeping it level. The pulp in the water will collect on the surface of the screen. (If the mold and deckle method is used, hold the **mold** so

(continued)

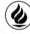

Making Paper *(continued)*

that the screen side faces up, then put the **deckle** over the mold. Dip the mold and deckle into the water together. Let the water drain before removing the deckle.)

6. Flip the screen onto the piece of felt so that the paper pulp is pressed against the felt. Lift the screen gently, starting at one corner. The screen will come away from the paper pulp.

7. Press the back of the handmade paper with a sponge to absorb excess water and press the fibers together.

8. Gently transfer the paper to a towel and let dry.

Additional Ideas

After you have tried the process, try experimenting with the paper pulp. Strings, straws, grasses, dried flowers, and so on can be "sandwiched" between two sheets of newly made paper before pressing. You can add glitter, onion skins, tea, or powdered paints to create a new effect. Different colors of pulp can be made into a pulp painting by arranging the wet pulp on a sheet of flat unpressed paper, then sponging the water out. Or shape and press the paper to create all sorts of effects! Experiment!

Illuminated Bookmark

The illuminated lettering seen in medieval manuscripts was created in monasteries by scribes. It was their job to copy these religious texts. The word *illuminate* means to brighten. These scribes were often talented artists. They decorated the text with beautifully designed lettering. They painted these with the richest colors of inks and paints available. Many contained crushed and powdered semiprecious gems and thin layers of gold leaf. The letters of the text glowed with meaning and beauty.

Materials

2" × 9" piece of drawing paper

Scissors

Markers, pencils

Clear adhesive paper, cut into $4\frac{1}{2}$" × 9" strips *or* laminating machine

Optional: $1\frac{1}{2}$" stenciled lettering

Procedure

1. Draw the first letter of a name or a brief saying at the top of the 2" × 9" strip of paper. If you cannot draw the letter freehand, use a lettering stencil to form the basic shape.

2. Next, embellish—beautify—the letter. Use a pencil to draw scroll designs, leaves, vines, animals, etc. Complete the word or saying on the rest of the card. The words can be written in a vertical or horizontal format.

3. Use markers or colored pencils to brighten, or illuminate, the design.

4. Remove the backing from a $4\frac{1}{2}$" × 9" piece of clear adhesive paper. Place the 2" × 9" paper on the adhesive paper. Fold the adhesive paper over the bookmark. Rub out any bubbles, if necessary.

Name _____ Date _____

Hole Punch Picture

Early American cabinets are known for their punched-tin designs. For example, punched tin was used for both ventilation and decoration in antique kitchen pie safes.

Materials

Corrugated cardboard
Construction paper
Nails (assorted sizes)

Procedure

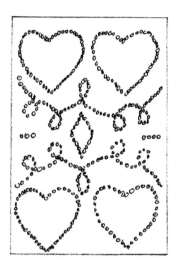

1. Place the cardboard on a table or desk (not on your lap!).

2. Lay the construction paper over the cardboard.

3. If you wish, draw a design on the paper before punching. Use the nails to punch through the construction paper into the cardboard. Use a variety of nail sizes. Group the holes to make a pleasing design.

4. Remove the construction paper and turn it over. Hang so that the punched side (back) is facing the viewer. For the best effect, display on a window or on a bright-colored background. The punched-out places form a relief pattern, highlighting the texture of your design.

Additional Ideas

- This activity can also be done with aluminum pie plates.

- Look into other uses early Americans made of hole punch designs.

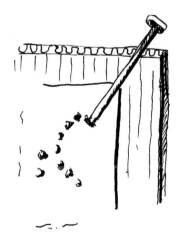

11 *Making Connections: Interdisciplinary Art Activities*

Name _____ Date _____

Paper Quilt Design

The art of quilting reaches back many generations. For early Americans, quilts provided both warmth and opportunities for socializing in "quilting bees," where neighbors gathered to work on a quilt together.

Historic quilts show how innovative the early quilters were. The colorful materials came from recycled cloth scraps. Some new scraps were too small to make anything else, while other scraps came from older items too precious to throw away. Most designs feature geometric shapes—shapes that are easily repeated and balanced.

Materials

9" × 9" squares of construction paper in primary colors (red, blue, or yellow)

$1\frac{1}{2}$" tagboard cutouts of geometric shapes

Construction paper in secondary colors (green, violet, orange, and so on)

Pencils

Scissors

Glue

Procedure

1. Choose three geometric shapes.

2. Trace and cut out at least six to eight of these shapes in the secondary color paper.

3. Arrange the shapes in a design on the square of primary color paper.

4. Glue the shapes in place.

Additional Ideas

• Arrange everyone's design on a large bulletin board to create a class quilt.

• A border can be made for each individual square by placing a 10" × 10" piece of paper behind the square.

Name _____ Date _____

Tangrams

Tangrams were originally ancient Chinese puzzles. They consisted of a square cut into seven basic geometric shapes. These shapes were reassembled into different figures. These basic shapes are found in many cultures. We see them in everything from Arabic tiles to early American quilt designs.

Materials

Tangram pattern (see pattern page)

Scissors

Optional: glue

Procedure

1. Cut the tangram master into its component shapes.

2. Arrange the tangram pieces so that they form a recognizable image—for example, a bird or a cat. Using graph paper, trace out a design using the shapes in the pattern.

Additional Ideas

- Choose a partner. Sit back-to-back. Create a picture from a set of cut shapes, then describe the picture and the placement of each piece to your partner. Guide your partner to re-create the same picture by listening to your instructions. Exchange roles.

- Make your designs permanent by gluing the shapes to a background board.

- Trace one or two tangram shapes to make a repeating pattern. Use markers or colored pencils to make a paper "quilt" square, like the one shown above.

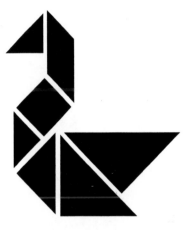

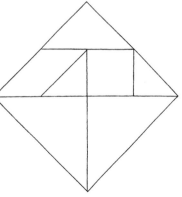

(continued)

Tangram *(continued)*

Pattern for Tangram Designs

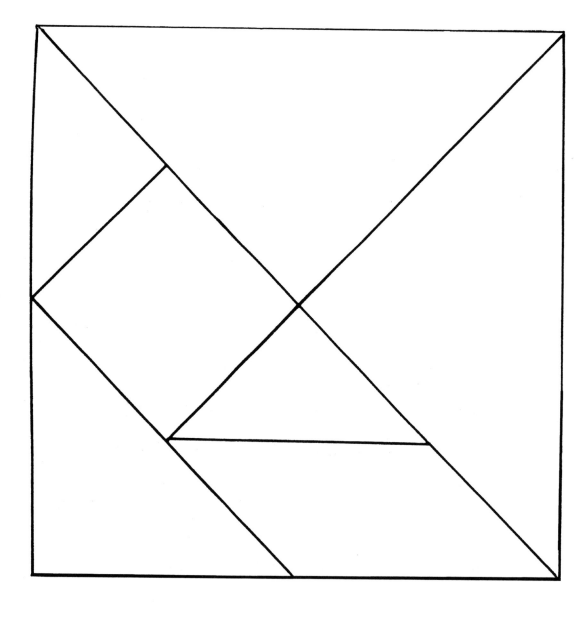

Chain of Hearts

In ancient Rome, the Festival of *Lupercalia* was celebrated on February 15. As part of the festival, girls wrote notes and put them in an urn. The young men pulled notes from the urn, then courted the girl whose note they drew. In A.D. 496, the pope wanted to change the festival to something less pagan. He moved the date of the festival to February 14, the feast day of Saint Valentine. Some elements of the pagan festival combined with the saint's day to create the popular sentiment of love and courtship. Today, valentines are still associated with "matters of the heart."

Materials

Papers of various colors for valentine hearts

Clear tape or glue

Scissors

1"-wide ribbon, 12" to 18" long

Procedure

1. Fold paper in half.

2. Cut out a large heart.

3. From the heart shape, cut another, smaller heart.

4. Continue until no more hearts can be cut out.

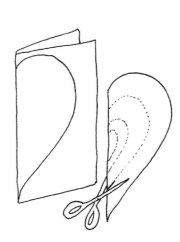

5. Tape the hearts in a row going down the ribbon, overlapping smaller and larger sizes. Hang the ribbon to display your chain of hearts.

Mola

The *mola* is a special textile design created by the Cuna Indians of Panama in Central America. The design has organic flowing shapes that appear to be geometric designs. They are brightly colored and at times overlap and repeat each other.

Materials

Pencils

Scissors

Construction paper in a variety of colors

Glue

Procedure

1. Select a sheet of colored paper. Fold the paper in half and cut a large abstract-shaped hole in the center. Open the paper. This is layer 1.

2. Place layer 1 on top of a different colored sheet of paper. Draw on this second layer of paper a cutting line similar but slightly different from the hole in layer 1. Cut along the cutting line to make a hole.

3. Place layer 2 on top of a third sheet. Repeat step 2.

4. Choose a fourth paper color. This fourth (and uncut) layer will be the base. Glue layer 3 to layer 4, layer 2 to layer 3, and layer 1 to layer 2.

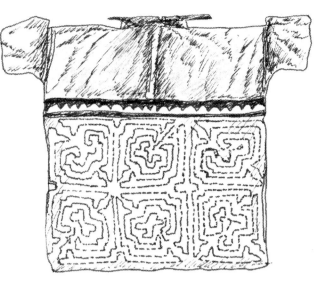

Appliqué blouse, Cuna, San Blas Islands, Panama
c. 1925 Length 25"

Additional Ideas

• Try using more layers of paper or cutting more than one hole in each layer.

• Use magazine pictures instead of construction paper.

Name _____ Date _____

Positive-Negative Design

The idea of positive versus negative is found in everything from science to religion. Within ourselves, we struggle with the pull of emotions that we label as positive and negative. Things that are opposite or very different are said to *contrast*. In art, shapes and colors that *contrast* in pictures and designs are easiest to see because they add excitement.

Materials

Construction paper (all colors or complementary colors only), 9" × 12" and 4$\frac{1}{2}$" × 6" or 6" × 9"

Scissors

Glue

Optional: pen or colored pencils

Procedure

1. Use two pieces of paper: one 9" × 12" sheet and one 4$\frac{1}{2}$" × 12 " or 6" × 9" sheet of contrasting or complementary colored paper. (Complementary colors are colors that are opposite each other on the color wheel. Red is the opposite of green, blue is the opposite of orange, and yellow is the opposite of purple or violet. Black and white are complementary colors.)

EITHER

2. On the smaller sheet, from the edge of the paper, draw shapes or designs that best reflect your personality. You can use a face or body motif or simply an abstract design.

3. Cut out the shapes or designs.

4. Placing the whole cut design on the larger background, "flip" one side of the cut design over and glue it down as if hinged.

Flip

(continued)

Positive-Negative Design *(continued)*

OR

2. On the smaller sheet, draw a simple design. Cut the shapes of the design out.

3. Lay these on your 9" × 12" sheet so that the space between them becomes a positive or negative mirror image.

4. Glue the the shapes in place.

Additional Ideas

- Follow the process above with smaller-sized paper. Repeat several times and combine to make one large picture.
- Which of the colors you used do you think is the positive color, and which is the negative color? Make a list of positive and negative emotions. Use a contrasting pen or pencil to list the positive emotions on the positive color, and the negative emotions on the negative color.

Name _____ Date _____

Op Art

Op art was developed in the late 1950's and early 1960's. It used opposite colors or complementary colors (for example, red and green) painted so close together that the eye could not focus on either color comfortably. (*Complementary colors* are colors that are opposite each other on the color wheel. Red is the opposite of green, blue is the opposite of orange, and yellow is the opposite of purple or violet. Black and white are complementary colors.) Many times the artist would use rhythm in the artwork to have the viewer move along with the piece. The word *op* in *op art* stands for "opposite colors" or "optical disturbance."

Materials

Construction paper, 9" × 12" or 18" × 24" in red, blue, yellow, green, orange, purple, black, and white

Glue or paste

Scissors

Procedure

1. Use a blue, violet, red, or black sheet of construction paper to use as a base sheet. Cut a sheet of green, orange, white, or yellow paper into a repeated design. See illustration.

2. Glue the strips down in the same order as cut, but $\frac{1}{4}$" to $\frac{1}{2}$" or so apart from each other. This will show the background color. There should be construction paper (yellow, orange, green, white) left over because of the gaps between strips. The thinner the strips, the better the effect.

Additional Idea

An op art effect can also be achieved with crayons, markers, or paint.

 Making Connections: Interdisciplinary Art Activities

Name _____ Date _____

Stained Glass

Light was one medieval symbol for God. During the medieval period, stained glass was widely used in European churches, decorating the churches with light. The great Gothic cathedral in Chartres, France, has 186 stained-glass windows.

Materials

Black construction paper

Tissue paper in various colors

Glue or glue stick

Scissors

Procedure

1. Fold the construction paper in half.

2. Cut sections out of the folded paper as if cutting a snowflake design. Try to keep a strip of paper at least $\frac{1}{2}$" wide between the cut-out sections. This area is where the colored tissue paper will be attached.

3. Cut the design with a border or use a mat to cover the edges of the finished design.

4. After opening the cut paper design, decide which colors are to be used in each section.

5. Trace the design of each section onto the colored tissue paper that will be applied to that section. Then draw a cutting line about $\frac{1}{4}$" outside the design. Making the tissue paper piece larger gives you room so you can glue the tissue onto the *back* of the design. Trace and cut or tear all tissue paper pieces.

6. Place glue on the back of the $\frac{1}{2}$" areas of construction paper, one section at a time. Put the tissue paper for that section in place, and press. Repeat until the design is completed.

7. Hang in a window or in front of a good light source.

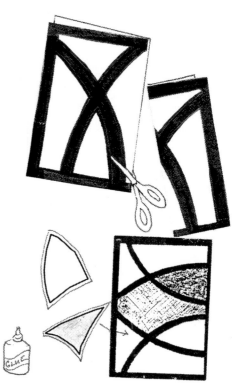

20 *Making Connections: Interdisciplinary Art Activities*

Sketching Ideas

A sketch is a rough drawing of an idea. Quite often, artists draw several small sketches for a picture. Then, they choose the best one to make a larger picture from that idea. A sketch does not have to be smaller than the finished art, but small sketches are easier and faster to draw. Small sketches save paper and can also be carried in a notebook. A personal journal or a journal of a trip will often contain sketches of the ideas conveyed in the writing.

Materials

Drawing paper

Pencils and erasers

Procedure

1. Fold your paper in half, top to bottom.

2. Fold it in half, left to right. When you open it you should have four equal parts.

3. While your teacher reads a story, draw what comes to mind in quick sketches. They do not have to be perfect! These are only creative thoughts, not masterpieces. Fill all four or eight squares (front and back) with ideas.

Additional Ideas

• Try keeping a journal of the week's activities. Include sketches in your descriptions.

• Try sketching the images instrumental music brings to mind.

• Create a large drawing of your best sketch; color or paint it.

Name _____ Date _____

Contour Line Drawing

Lines show where the edges of objects are. Some lines show the outside edges of objects. Other lines show edges that are inside the main shape. Both kinds of lines are called *contours*.

To draw in contour lines is to create a picture with one continuous line. Think of an ant that has crawled through a puddle of ink. This ant leaves a thin trail of ink wherever it goes. When you draw in contour lines, think of that ant crawling over your object . . . in . . . out . . . over and around.

Materials

Paper

Crayons, pencils without erasers, or felt-tip markers

Interesting small objects (e.g., stapler, seashell, pen, can, fork)

Procedure

1. Feel the contours of an object. Close your eyes and feel the object. Does it feel the same? Did you discover any new contours of the object?

2. Take an object out of the bag provided by your teacher as it is being passed under your desk or table. Don't look at the object.

3. Draw this object in a contour line on your paper, feeling the object as you draw. Be sure not to look at the object.

Additional Ideas

- Using a contour line, draw a student model, concentrating on the main lines of the person. Remember that ant crawling over and around. Keep it simple!

- Create a "ghost picture." Contour line objects may be left plain while the background is colored in to create a scene (positive-negative space).

- Write a description of the ant's journey from the ant's perspective.

 Making Connections: Interdisciplinary Art Activities

Perspective

Find examples from newspapers or magazines of 3-D lettering. The 3-D effect is achieved by *perspective drawing*. Perspective drawing is a way of creating the illusion of depth in a picture. This illusion is created by the horizon line—the place where the earth meets the sky.

Materials

Ruler

Pencil with eraser

Paper

Procedure

1. With the ruler, draw a line across the piece of paper. This is the horizon line.

2. Place a point on the horizon line. This is called a *vanishing point*. As lines recede they become closer together visually. The closer they are to the viewer, the farther apart they seem. As they get farther away they meet at the vanishing point.

3. Draw a one-inch square below the horizon line and vanishing point you have drawn.

4. Color the square in with crayon or pencil.

5. Now, using a ruler, draw a line from each corner of the square to the vanishing point.

6. Between the lines just drawn between the box corners and the vanishing point, draw the far end of the block. Erase the leftover lines.

Additional Idea

Try to draw a block letter. Draw the letter in perspective as described above. Try initials, names, or words.

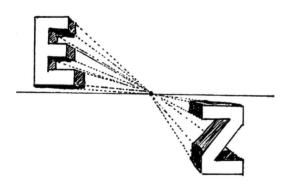

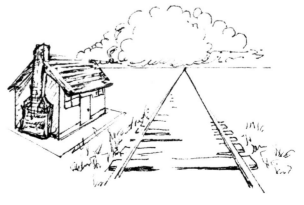

Name _____ Date _____

Stargazing

From earliest times, people have tried to make sense of the night skies. They discovered that mathematical study of the movement of these heavenly bodies was the key to understanding. Mythology played a large part in naming these mathematical discoveries. The names of the constellations *Orion, Pegasus,* and *Andromeda* all come from Greek myths.

Materials

Graph paper

Ruler or straightedge

Pencil

Procedure

1. Select a place on the graph paper and mark it with a point.

2. Add 5 points above, below, and to each side of the center point as shown. This will divide the paper into quadrants. Number the points from the center (1) outward (to 5).

3. Draw a line from point 1 on one axis to point 5 on the other axis. (Fig. A)

4. Next draw a line from point 2 to point 4. Now draw a line from point 3 to point 3. (Fig. B)

5. Draw a line from point 4 to point 2. Then draw a line from point 5 to point 1. (Fig. C)

6. Repeat steps 3 to 5 in the other three quadrants. You may draw a line to connect the center points. This star design creates an optical illusion in the way it seems to pull toward the viewer. (Fig. D)

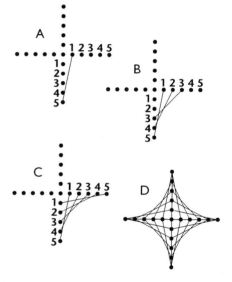

Additional Ideas

• Randomly place 15 dots on another sheet of paper. Try to see your own constellation in the points.

• Draw the shape of your "constellation" by connecting the points, much like a real star configuration. Name the constellation.

• Write an original myth about it.

24 *Making Connections: Interdisciplinary Art Activities*

Cartoons

Look at cartoon figures in the Sunday comics. See the simple expressions made with the characters' eyes. These drawings can say whatever they need to by adding just a dot or a line in the right place.

Materials

Paper

Pencils

Black stamp pad

Black pen (ballpoint or felt-tip)

Procedure

1. On a piece of drawing paper or a piece of notebook paper, draw 10 pairs of circles (eyes).

2. Put expressions in the eyes. Use two small dots for a nose, and create a mouth with a line. Now, you have the start of a character.

3. Experiment with fingerprints. Using the stamp pad, make a few fingerprints. Create a cartoon figure or figures on the paper. All you need is a few simple lines to express what the character is.

4. Now, create a comic strip. Section off the paper into 3 or 4 frames for the comic strip. Frames are the boxes that show the progress of the story. Think of a plot for your strip. The plot is the what the story is about. Write a punch line or creative ending.

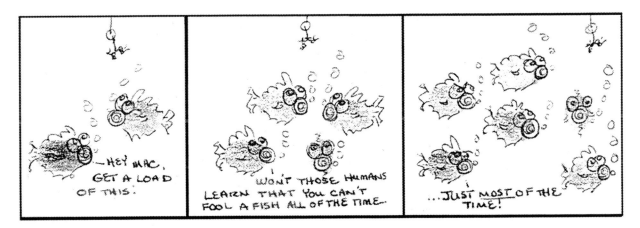

Name _____ Date _____

Texture

Textures are everywhere. We see textures with our eyes. We feel textures with our bodies. (Braille is a technique of reading that relies on the sense of touch.) We hear textures with our ears. (Music is texture of sound or rhythm.)

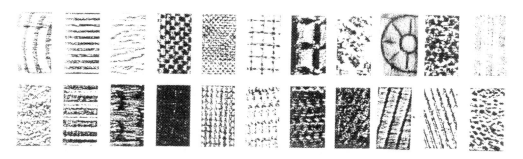

Materials

Large (preferred) crayons without wrappers

Newsprint, notebook paper, or drawing paper (not too thick)

Textures in the room

Procedure

Texture rubbings are made by placing paper over an object and rubbing the paper with a crayon or pencil to produce a rough image. Surfaces can vary, so thousands of textures exist. In your classroom see what textures can be found and recorded this way. Many interesting textures can be found on things as simple as shoes, belt buckles, hair clips, etc.

1. Divide a sheet of paper into 26 sections with lines.

2. Begin a scavenger hunt exercise to find enough textures to fill the 26 sections. Be sure to label the textures as they are found.

3. Create an actual picture out of rubbed textures on another sheet of paper. (It may be drawn first with pencil or crayon.) Stress the use of different textures.

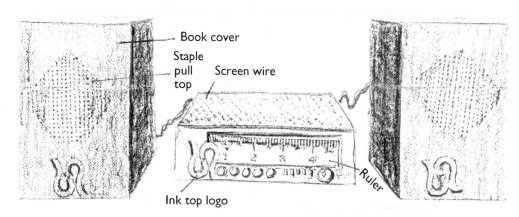

Bookbinding

The folded book as we know it was not used in the Western world until the first few centuries of this millennium. During the Middle Ages so few people in the West knew how to read that books were almost exclusively produced by hand and preserved in monasteries. Eventually whole pages of words were carved out of wood and printed onto paper. Even this method was slow and costly. (Just to *own* a book was very special even if you could not read it!) Not until the early 1400's did Johannes Gutenberg of Germany develop the movable type that made the printing of books easier and less expensive. Today, with the mechanization of the printing industry, millions of books are published a year around the world. Try writing your own story in your book!

Materials

Four to five sheets of paper

Poster board (1" larger than the size of the paper)

Dental floss or strong thin string (approximately 1 yard)

Large sewing needle

Glue

Optional: marbled paper for cover

Procedure

1. To bind a book in a simple way, take four or five sheets of plain or lined paper. (Try making your own paper! See "Papermaking.")

2. Fold the paper in half.

3. With a large sewing needle, make holes in the spine (folded edge) of the folded paper.

4. Thread dental floss into the needle. Sew back and forth through the spine until it seems securely held together. Make as many of these sections as needed. Printers call these *signatures*.

5. Glue or sew the signatures together.

6. Fold the poster board cover in half.

7. Glue the first and the last page of the folded group of papers onto the inside of the poster board cover. If desired, apply a marbled paper covering.

Name _____ Date _____

Eggshell Mosaic

Imagine some scaly animals. Or what about a mythological animal such as a dragon? The people of ancient Greece used small, naturally colored stones to design pictures called *mosaics* on their floors and walls. Many of these show all sorts of strange creatures in their designs. Some of these mosaics have survived for thousands of years. Write a story about a scaly creature and illustrate it with a mosaic.

Materials

Eggshells (cleaned and dried)

Watercolor paints or markers

White glue

Tag or poster board (any color)

Procedure

1. Draw a simple outline of a scaly creature on the tag or poster board.

2. Cut the shape out.

3. Spread glue on a small area of the shape.

4. Pinch off a piece of the eggshell. Place it on the glued area with the outside of the shell facing up to show its texture. Repeat until the entire shape is filled.

5. Once it has dried, paint your creation with watercolors. Or, if you use markers, brush the eggshells lightly after applying the color to spread the colors in the cracks.

Painting and Printmaking Activities

Although the first seven activities in this section involve general techniques rather than specific projects, they are included because they offer ways to create unique projects involving the painting process.

Painting involves wet and dry media used together in a variety of ways. Paint does not have to be applied with a paintbrush. Many teachers shy away from painting because of the mess involved. A good way to avoid this problem is to designate a special corner for painting. Stock the area with newspapers, water, and large shirts or smocks. Students work best when one or two of them are allowed to paint at a time while the rest of the class is doing other work. This keeps order, and the end result is very positive for everyone.

Teachers of special needs students may want to gauge their abilities in the individual painting methods, as well as their reactions to the methods. Some children are repelled by the smell or feel of the paint that they are to use. Others may become so excited about being introduced to the new process that they lose control. Projects such as Squeegee Painting, Pulled String Design, and Blottos are less involved and thus may be better for these students.

Powdered Dye Sprinkle Painting (p. 35) _____

Themes

- Science: action/reaction
- Art: Impressionistic and abstract painting

Objectives

Students will:

- experience success with an open-ended art process
- have an opportunity for creative expression
- experiment with cause-and-effect relationships

Preparation

- Place the powdered dyes or paints in salt shaker-type containers.
- When spraying to fix the paint, allow for good ventilation.

Pulled String Design (p. 36) _____

Themes

- Science: wind currents
- Art: repetition of design

Objectives

Students will:

- experience success with an open-ended art process
- have an opportunity for creative expression
- experiment with cause-and-effect relationships

Preparation

- Paints will need to be slightly thinned before class.

Bubble Doubles (p. 37) _____

Themes

- Science: cell division
- Math: geometric designs

- Art: natural designs, visual texture

Objectives

Students will:

- experience success with an open-ended art process
- have an opportunity for creative expression
- experiment with cause-and-effect relationships

Special Tip

- Make sure that special needs students blow gently into the straw, being careful not to **inhale** instead of exhaling.

Bleach Painting (p. 38) _____

Themes

- Art: positive-negative designs
- Science: chemical reactions

Objectives

Students will:

- experience success with an open-ended art process
- have an opportunity for creative expression
- experiment with cause-and-effect relationships

Preparation

- Provide good ventilation in the work area. Use caution with chlorine.

Squeegee Painting (p. 39)_____

Themes

- Art: basic color theory, color field painting
- Science: cause and effect

Objectives

Students will:

- experience success with an open-ended art process
- have an opportunity for creative expression
- experiment with cause-and-effect relationships

Sponge Painting (p. 40) _____

Theme

- Art: textures
- Science: various sponge impressions

Objectives

Students will:

- experience success with an open-ended art process
- have an opportunity for creative expression
- experiment with cause-and-effect relationships

Preparation

- Wet sponges with water and squeeze out to make the sponges softer.

Splatter Painting (p. 41)_____

Themes

- Science: botany (if leaves are used as stencils)
- Art: splatter paintings and painters; design and color placement in paintings

Objectives

Students will:

- experience success with an open-ended art process

- have an opportunity for creative expression
- experiment with cause-and-effect relationships

Preparation

- You might wish to cover as much of the work area as practical with newspaper, as this activity could get quite messy.

Blottos (p. 42) _____

Themes

- Language arts: creative writing about figures created from blottos
- Science: Rorschach testing
- Art: creative imagery

Objectives

Students will:

- create realistic figures from abstract shapes
- develop their imaginations

Special Tips

- Special needs students may have success with this activity if you control the dropping of the paint. They may need to lay the folded paper on top of paper toweling to catch any paint being squeezed out. Encourage them to talk about their creations.

Marbleized Paper (p. 43) _____

Themes

- Art: decorative arts, calligraphy
- Chemistry: oil and water
- History: early European bookmaking

- Language arts: creative writing

Objectives

Students will:

- create a natural, organic design
- explore the concept that oil and water do not mix

Special Tip

- With close supervision, the expanding of the oil paint in the water and the quick results will make this a successful activity for special needs students. Be careful that the oil paint does not get on the student. There are alternative products on the market that produce the same results without the clean up problem. Try oil-based colors used in candy-making, available in craft and department stores.

Tissue Paper Tie-Dye (p. 44) _____

Theme

- Social studies: Indian, South American textiles
- Art: color mixing and design

Objectives

Students will:

- learn to fold paper in different ways
- learn principles of absorption
- learn basic color mixing theory

Special Tip

- Special needs students may find this activity messy and the delicacy of unfolding the paper hard to handle. Base the chances of success on the ability of the student involved.

Crayon Batik *(p. 45)* _____

Theme

- Social studies: Indonesian textiles, batik
- Art: fabric design

Objectives

Students will:

- explore fabric design
- use a simple type of crayon batik

Special Tip

- Special needs students may find this activity difficult due to the pressure needed to color on the cloth and the ironing technique.

Crayon Engraving *(p. 46)* _____

Themes

- Language arts: book illustration
- Art: simple form of a printmaking concept
- History: early bookmaking and illustration

Objectives

Students will:

- learn a simple form of engraving
- create different textures by combining various scratching techniques

Preparation

- Cover the work area with newspaper.

Special Tips

- Special needs students may find this activity difficult in conception because the crayoned drawing is totally covered over in black. You may want to prepare the crayon background for

them, so that they need only scratch away the black paint.

- The messy residue from scratching off the surface paint can be a problem for some.

Crayon Shaving Cards *(p. 47)* _____

Themes

- Language arts: card writing
- Social studies: holiday cards
- Art: encaustic painting

Objectives

Students will:

- create a simple encaustic painting
- create unique greeting cards

Preparation

- Collect crayon shavings from other activities prior to this one.

Special Tip

- Special needs students should find this activity easy provided they are supervised very closely when using the iron.

Snowflake Resist *(p. 48)* _____

Themes

- Science: oil and water, snow formation, earth's snow mass
- Social studies: seasonal decorations
- Art: design

Objectives

Students will:

- experience a cause-and-effect relationship
- create a symmetrical abstract design

Special Tip

- Special needs students will find this activity a challenge because of the intricate cutting.

Sand-Painted Postcards (p. 49) ____

Themes

- Science: soil, minerals
- Social studies: Native American arts and crafts
- Art: Native American art form

Objectives

Students will:

- create artwork with an unusual medium
- become familiar with a Native American art form

Preparation

- For each color of sand, thoroughly mix 1 teaspoon food coloring with 1 cup sand. Spread on tinfoil and bake in an oven at 350°F until dry.
- Provide for good ventilation in the work area.

Special Tips

- Special needs students may have success with this activity if the design is predrawn on the card.
- You need to be very organized in the setup and execution of this activity to avoid potential messes.

Leaf Printing (p. 50) _____

Themes

- Science: fossilization, patterns in nature, seasons of the year
- Art: printmaking

Objectives

Students will:

- create a fossillike impression
- observe different shapes in leaves
- observe the color combinations of nature in fall

Special Tips

- Special needs students may have success with this activity if they do not mind getting paint on their fingers.
- Given the permanent nature of acrylic paint after it is dry, close supervision is needed.

Vegetable Printing (p. 51)_____

Demonstrate the printing techniques to the class. Have students print a practice sheet before trying the stationery or wrapping paper.

Themes

- Science: plant designs and textures
- Social studies: holiday wrapping paper
- History: early bookmaking and printing methods
- Art: block printing

Objectives

Students will:

- work with alternative printing materials
- create a useful object

Preparation

- Cut the various vegetables ahead of time. Onions should be cut the night before to give them time to dry.
- Cover tables with newsprint.
- Pour paint onto the sponges in the dishes to make "stamp pads."

Special Tips

- Special needs students may find this activity fascinating, especially if they are studying vegetables or designs in nature.
- Some students may be disturbed by getting paint on their fingers.

Fish Printing (p. 52) _____

Themes

- Science: fossilization, fish anatomy (scales)
- Social studies: textile design, Japanese art and history
- Art: relief printing

Objectives

Students will:

- discover a new printing medium
- observe the fossillike texture of fish

Preparation

- You will need to procure the frozen fish before class. If you prefer, rubber fish replicas designed specifically for gyotaku are available from Nasco, Inc. (1-800-558-9595)

Plastic Foam Printing (p. 53) _____

Themes

- Science: mirror images
- History: early printing and bookmaking methods
- Art: block printing
- Language arts: writing creatively to go along with print

Objectives

Students will:

- create a printed image from an easily obtainable material
- understand "mirror imaging" through the printing process

Preparation

- Collect plastic foam meat trays prior to this class. Ask students to bring in clean ones as well.

Special Tip

- Special needs students may find this activity easy with supervision in cutting the plastic foam and applying the ink or paint to its surface.

Name _____ Date _____

Powdered Dye Sprinkle Painting

Materials

Paper

Water

Various colors of powdered paint or dye in salt shaker-type containers

Hair spray or fixative

Procedure

1. Dampen paper, then sprinkle dye onto the paper.

2. Allow to dry.

3. Spray the dried paper with hair spray or fixative.

Pulled String Design

Materials

String (approximately 20")

Heavy book or board

Slightly thinned paint in shallow containers

Paper

Procedure

1. Fold the paper in half.

2. Dip the string into the paint, coating it thoroughly. Gently squeeze off the excess paint with fingers.

3. Arrange the string in loops and wiggles on one half of the open folded paper. Be sure one end of the string is at the edge of the paper so that you can pull it.

4. Refold the paper.

5. Place a book or board on top.

6. Pull the string gently. The design made by the moving string will be duplicated on each half of the paper.

Name _____ Date _____

Bubble Doubles

Materials

A small jar for each paint color you will use

Water

Paints or food dye of various colors

Straws

Dishwashing liquid

Measuring spoon and cup

Paper

Procedure

1. Mix two tablespoons of dishwashing liquid and $\frac{1}{4}$ cup water in a small jar.

2. Add about 1 teaspoon of paint. The more paint, the darker the color.

3. Mix well.

4. Insert a straw and blow gently into the mixture until the bubbles cluster at the top of the jar.

5. Place the paper on the bubbles. The bubbles will break and leave their imprints on the paper. Overlap colors and vary placement of the paper for interesting effects.

Bleach Painting

Materials

Chlorine bleach in glass container

Cotton swabs

Colored construction paper

Rubber gloves

Optional: smock

Procedure

Dip a swab in the bleach. Draw a picture or design on the colored paper. The bleach will remove the color from the paper. (Note the quality and color of different papers and their reaction to the bleach.)

Name _____ Date _____

Squeegee Painting

Materials

Food coloring

Small squeegee (cardboard or mat board)

Paper (copier paper works best)

Procedure

1. Place one drop of each color of food color in a line across one end of the paper, not too far apart.

2. Pull the squeegee across the paper, dragging the colors as they blend.

Additional Idea

- Experiment with different color combinations—primary colors, complementary colors, and so forth. Which combinations give the most satisfactory results?

Name _____ Date _____

Sponge Painting

Materials

Sponges with different textures cut into various shapes
Shallow containers of paint
Paper

Procedure

1. Dip the side of the dampened sponge into the paint.

2. Wipe off excess paint.

3. Press onto the paper, creating a design or a picture. Note the textures made by various natural or artificial sponges.

4. Explore the different effects made by the sponges. Try twisting and turning the sponge as you press it onto the paper.

Additional Idea

Use acrylic paint and sponges to print on fabric.

Name _____ Date _____

Splatter Painting

Materials

Old toothbrush

Paints in shallow pans

Stencil of some type (shapes, leaves, any design will do)

Paper

Procedure

1. Dip the bristles of the toothbrush into a pan of paint.

2. Place a stencil on top of your paper.

3. With a thumb or finger, brush the bristles of the toothbrush until the paint is flicked all over the paper with the stencil. Experiment with colors and overlapping.

Blottos

Materials

Paper, $4\frac{1}{2}" \times 6"$

Scissors

Background paper, $12" \times 18"$

Glue

Paint in squeeze bottles

Procedure

1. Fold a sheet of paper in half.

2. Place three or four small drops of colored paint on one half of the folded paper. (Using less paint gives better results.)

3. Refold the paper, pressing to create *one* design with the paint drops.

4. Open the paper to reveal the interesting shapes created by this process.

5. Repeat the process with several more pieces of paper.

6. When all paint blottos are dried, create a picture using the shapes. Cut them out and paste them into a scene or picture. You may trade blottos.

7. Color or paint the rest of the scene.

Name _____ Date _____

Marbleized Paper

Marbleizing paper is a very old process used to decorate manuscripts and books. The original process was very involved. It used special ingredients from animals and plants. Today, this process can be easily done in the classroom.

Materials

Oil-based enamel paint (various colors)

Toothpicks

Shallow pan ($1" \times 8" \times 10"$)

Paper cut to fit inside the pan

Water

Procedure

1. Fill the pan with water.

2. Dip a toothpick into the paint and dribble a small amount over the surface of the water. The paint will spread out on top of the water because of the oil it contains. Try various colors of paint, but remember, less is best.

3. Use a toothpick to swirl the colors around to make interesting designs.

4. Place the paper on the surface of the water.

5. Gently press it onto or drag it across the surface of the water.

6. To clean the water surface before making the next design, drag a piece of scrap paper or paper towel over the water until it is clean.

Additional Idea

Your marbleized paper can be used in various ways. Try gluing it onto a piece of poster board to create a cover for an original book.

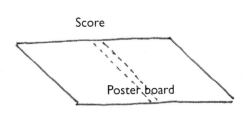

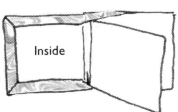

43 *Making Connections: Interdisciplinary Art Activities*

Name _____ Date _____

Tissue Paper Tie-Dye

The popular tie-dye designs on today's fashions were influenced by the cultures of India and South America. Tie-dye is used for creating a pattern. You can create many designs depending on the way in which you fold the paper.

Materials

Coffee filters, ironed (used round or cut to squares) —or—

White tissue paper or paper towel, 10" × 15"

Food coloring

Water

Small bowls

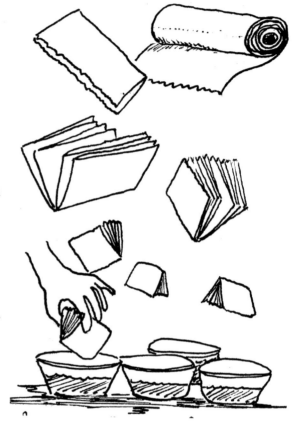

Procedure

1. Fold the tissue paper in a fanlike style from top to bottom.

2. Fold the paper in half.

3. Dip one corner of the finished paper shape into one color of dye.

4. Dip the opposite corner into another color. The dips should be quick because the paper absorbs the dye rather quickly.

5. Gently unfold the paper and let dry.

6. Try various ways of folding and dipping the paper. Too much of too many colors creates a mess, so keep it simple!

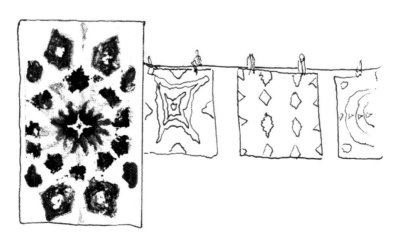

44 *Making Connections: Interdisciplinary Art Activities*

Name _____ Date _____

Crayon Batik

This is a much-simplified version of a technique of fabric design used in Indonesia called *batik*. Batik uses wax and dyes on fabric to create a pattern. In the original process, designs are stamped onto cloth with wax or drawn with a small tool that holds liquid wax. The cloth is dipped in dye. The waxed areas resist the dye, so they stay the original color. When the dyeing is completed, the wax is melted out of the cloth. The color pigment in the wax crayon used here will act as the dye would normally. The colors left in the cloth will become semipermanent if the cloth is washed in cool water without detergent.

Materials

Piece of muslin or cotton cloth (any size), washed, or an all-cotton T-shirt

Crayons

Iron

Newsprint

Procedure

1. Draw directly on the cloth with the crayons, using pressure. Color hard!

2. When the drawing is finished, place the cloth between several layers of newsprint. With the iron set on medium-high, press a minute or so on the newspaper-covered cloth. The paper will absorb the wax and leave the pigment in the cloth.

3. Change the paper as many times as needed to absorb all the wax.

45 *Making Connections: Interdisciplinary Art Activities*

Crayon Engraving

The book illustrations of the nineteenth century were created by cutting, or *engraving*, a design into a piece of hard wood or into metal plates with sharp tools. These plates were covered with ink and printed in open spaces left in the text. Tiny thin lines were used in these pictures to show light and dark areas. You can use lines to create texture in a crayon engraving.

Materials

Wax crayons

Drawing paper

Scratching tool (scissors, stick, hairpin, comb, nail, paper clip, nail file, etc.)

Black tempera paint with liquid detergent, dark crayons, or acrylic paint

Procedure

1. Using light, bright crayons, color solidly a picture or design in a free or planned pattern. (Limit to three to four bright colors.)

2. Press heavily, covering all areas of the paper.

3. Using black crayon, acrylic paint, or tempera paint with detergent, cover all the crayoned area.

4. With a sharp tool, sketch a picture directly over the black. Scrape away the black material with the tool, making lines that are thin, thick, wavy, and so on. Create many textures and pictures.

Crayon Shaving Cards

The Greek word *enkaustikos* means "burning in." *Encaustic* painting is a method of painting invented by the ancient Greeks. It involves melting wax and color together to create a brilliant textured painting. Contemporary artist Jasper Johns often uses this ancient method of painting.

Materials

$5\frac{1}{2}$" × 9" white paper

Crayon shavings

Two sheets of 9" × 12" paper

Pencils or pens with which to write message

Iron

Aluminum foil

Procedure

1. Turn the iron on to warm.

2. Fold the sheet of $5\frac{1}{2}$" × 9" white paper in half.

3. Write a message on the inside bottom half of the folded card.

4. Open the card and place it, message side down, on a 9" × 12" sheet of white paper.

5. Lightly sprinkle crayon shavings onto the top half of the card. They may be arranged into a shape and ironed or left as they fall on the paper to create a less structured design. (Holiday cards are very appealing created in this manner.)

6. Cover the card with a sheet of foil larger than the card.

7. Cover the foil with the second piece of 9" × 12" white paper.

8. Place the warm iron on the top sheet of paper and slowly move it over the surface of the covered card. It will only take a short while to melt the crayon shavings.

9. Remove the foil once the card has cooled.

Snowflake Resist

Snow deposits may occasionally cover as much as 23 percent of the earth's total land surface! That is a lot of snow—especially when you think of how small a snowflake really is. Snowflakes consist of small crystals of frozen water that fall through the atmosphere. When the crystals cluster together, they form snowflakes. Snow crystals occur in an almost endless variety of designs that are *hexagonal* (six-sided). The shape and size of the designs depend on the temperature and the amount of moisture in the air.

Materials

Waxed paper (about 4" × 4")

White paper

Scissors

Diluted tempera paint *or* watercolor paint *or* ink

Iron

Newspaper

Procedure

1. Fold a square of waxed paper in half, then into fourths. (For best results, use a hexagon—a six-sided shape—to create the snowflake.)

2. Cut small geometric designs out of the edges of the paper, making sure that a few of the folded areas are left intact.

3. Unfold the snowflake. Repeat with different designs.

4. Set the designs, waxy side down, on a piece of white paper. Place the paper on newspaper. Put a piece of scrap paper on top of the snow-flakes.

5. Iron over the top sheet of paper. This will transfer the wax from the waxed paper to the white paper.

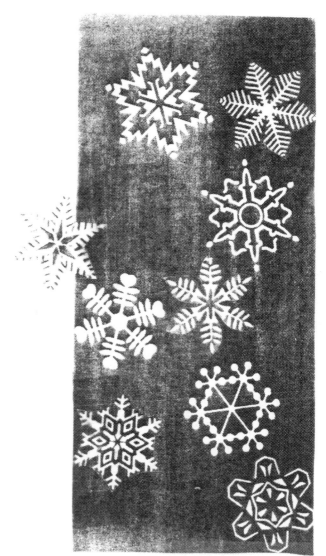

6. Paint or sponge the white paper with color. The waxed areas will resist the color, and will stay white. Several flake designs can be arranged on the white paper before ironing to create a flurry of snowflakes.

 Making Connections: Interdisciplinary Art Activities

Sand-Painted Postcards

The Native Americans of the American West use sand paintings in sacred ceremonies. They use certain symbols to give pictures special meaning. The natural colors of sand vary due to different minerals in the earth.

Create your own special symbols for your design.

Materials

Colored sand

White glue

Poster board, 4" × 6" or larger

Pencils

Spoons

Bowls (one for each color of sand used)

Procedure

1. Lightly sketch a design with pencil on the poster board.

2. Choose the areas of the design that are to be one particular color of sand. (You may want to lightly pencil a number in each area, to make it easier to keep track.)

3. Apply glue to those areas.

4. With a spoon, sprinkle the colored sand onto the glued areas.

5. Allow the work to dry for a few minutes. Then lift the picture and tap lightly into the bowl or on another piece of paper to remove excess sand.

6. Repeat with additional colors and designs, using one color of sand at a time.

Name _____ Date _____

Leaf Printing

In many parts of the country, Autumn brings leaves of many colors drifting down from the trees. Not all leaves are the same shape or color. After leaves fall, many wind up underground as they are gradually covered by other materials. Over millions of years, the materials around the leaf may become rock. The leaf itself becomes just the impression of the veins, a sort of leaf skeleton called a *fossil*.

Materials

Leaves of various sizes and shapes

Sponge in a shallow saucer-like container

Black acrylic paint

Watercolor paints

Paper

Paintbrushes

Bowls of water for cleaning brushes

Procedure

1. Pour acrylic paint onto the sponge until it is saturated with paint.

2. Rub the excess paint off the surface of the sponge.

3. Gently press the back of the leaf on the sponge to pick up paint on the veins of the leaf.

4. Place the leaf onto the paper and press gently to print the leaf. You may want to outline the leaf shape with a pencil before lifting the leaf off the paper.

5. Let the print dry.

6. Paint the print with various fall colors. Once it has dried, acrylic paint will not be affected by watercolors.

Vegetable Printing

The printing process used in vegetable printing is called *relief printing*. It uses the raised part of an object to transfer paint to a surface. Relief prints are the oldest type of printing known. Early relief prints were carved from wood and printed onto cloth. This type of printing leaves a bold impression of the design that has been carved. Many of the vegetables listed below are easy to carve, and some create unique and beautiful designs just as they are.

Materials

Various vegetables: potatoes, carrots, apples, okra, celery, onions, string beans, corn, half a cabbage, mushrooms

Paint of various colors or block printing ink

Jar lids or shallow containers with sponges and paint

Paper

Procedure

1. Choose a variety of cut vegetables. Look for different textures and shapes.

2. Press the cut vegetable onto the "stamp pad" sponge so that it picks up a thin coating of paint.

3. Press the vegetable onto the paper to transfer the paint.

4. Combine different shapes and colors to create a picture.

Additonal Ideas

- For stationery, design a card or sheet of stationery using vegetable prints. Carve names or initials in reverse on the vegetable so that the letters will be printed correctly.

- For wrapping paper, use kraft paper or any solid paper surface. Cut Christmas tree shapes or other designs into the vegetables and cover the paper with the vegetable-printed decorations.

Okra

Green bean

Cut carrot

Celery

Mushroom

 Making Connections: Interdisciplinary Art Activities

Name _____ Date _____

Fish Printing

Gyotaku (pronounced guh-yo-tah-koo) is Japanese for this type of special fish impression. "Gyo" means fish and "taku" means impression.

Fishing is very important in Japan. Long ago, before refrigeration, when a fisherman caught a large or unusual fish, it was impossible to keep it to show to friends or other fishermen. The solution was to make a print of the fish and have it forever in a more convenient form. Today these prints are extremely rare and valuable. I am sure the prize catch was delicious!

Observe how the fish print looks like a fossil imprint. The texture that was printed is the *relief image* of the outside of the fish. You might even be able to see the lateral line, which is a nervelike organ running down both sides of the fish that helps sense low-frequency vibrations.

Materials

Frozen ungutted whole fish

Black block printing ink *or* black acrylic paint (slightly diluted with water)

Stiff-bristled brush

Crayons

Newsprint *or* thin typing paper

Procedure

1. Blot the fish with a paper towel until excess water and juices are gone and the fish is fairly dry. The thawing of the fish creates a slight moisture in the beginning, but this will disappear after the first few prints.

2. Dip a paintbrush into the ink. Wipe off the excess ink.

3. Brush a *thin* layer of ink onto the fish.

4. Place the paper on the fish, holding it in place at all times.

5. Pass the paper *gently* down all over the fish.

6. Lift the paper. (The first prints will not be quite as clear, due to the moisture described above.)

Additional Ideas

- After the print dries, use crayons to color the body of the fish and a scene around the fish. If acrylic paints are preferred, watercolor markers or paints may be used to add color.

- Create a fish shirt by printing onto a cotton T-shirt.

Styrofoam Printing

The relief printing process is the oldest and easiest method of printmaking. The fifteenth-century German artists Hans Holbein (1497–1543) and Albrecht Dürer (1471–1528) excelled in the art of the relief print. All images carved into a block become a mirror image when printed.

The relief print was, and still is, a very effective way to illustrate. Remember that any text on the plastic foam image needs to be carved backward.

Materials

Plastic foam meat trays (free of printing or scratches)

Paint *or* water-based black print ink

Brayer (inking roller) *or* paintbrush

Scissors

Pencil or pen

Spoon

Paper

 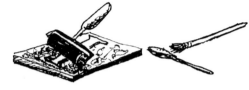

Procedure

1. Cut the upturned edges off the meat tray to obtain a flat surface.

2. With a pencil or pen, draw your pictures on the plastic foam. Drawings do not need to be very deep, but the line should make an indent on the foam.

3. Roll or paint ink onto the surface of the plastic foam. Any excess paint in the grooves can be cleaned out with a pencil.

4. Place the paper on the inked side of the plastic foam.

5. With the spoon, rub the paper to transfer the ink to the paper. When all areas have been rubbed, take the paper off. More than one image can be made. If the plastic foam plate is washed off to print again in another color, make sure the grooves are wiped free of water.

Additional Idea

• Try illustrating a story of your own with plastic foam prints.

3-Dimensional Activities

Pyramids and Polyhedrons *(p. 63)* _____

Themes

- Social studies: Egyptian, Mesopotamian, Aztec temple design and religion
- Science: crystal formation
- Math: 3-dimensional geometric shapes
- Art: art history, geometric design, architectural design

Objectives

Students will:

- create a 3-dimensional geometric shape
- use imagination to create a structure
- learn about several ancient religions

Preparation

- You may wish to enlarge the patterns on the photocopier ahead of time.

Special Tip

- Special needs students may find this activity difficult because of its technical nature. Patterns should be enlarged to make them easier to work with for students with poor fine motor skills.

Paper Cup *(p. 67)* _____

Themes

- Social studies: Japanese origami
- Math: 3-dimensional geometric shapes
- Language arts: story writing

- Art: paper folding

Objectives

Students will:

- create a useful object from paper
- use imagination in its application

Special Tip

- Special needs students may find this too challenging unless the folding is demonstrated on a one-on-one basis. Even then students with fine motor problems may lack the precision needed to successfully form the cup.

Mobius Magic *(p. 68)* _____

Themes

- Mathematics
- Social studies: nineteenth-century German learning
- Art: paper manipulation

Objectives

Students will:

- visually experience a mathematical concept
- develop paper manipulation skills
- develop an understanding of measurement

Special Tip

- Although special needs students may find it hard to carry out this activity by themselves, the sheer illusion will fascinate them.

Spiral Breeze Catcher (p. 69) _____

Themes

- Science: meteorology, air currents
- Art: kinetic sculpture
- Math: dynamics of a spiral

Objectives

Students will:

- create a kinetic sculpture
- observe how gravity and wind currents can create movement

Preparation

- You may wish to enlarge the pattern on the photocopier ahead of class.

Special Tip

- Special needs students may find this activity difficult. Try pre-cutting the spirals so that students only need to open and suspend the finished product.

Pinwheel (p. 71)_____

Themes

- Science: conversion of energy, wind speed, wind power, law of conservation of energy
- Social studies: Dutch windmills and industry
- Art: kinetic sculpture

Objectives

Students will:

- create a kinetic sculpture
- use fine motor skills

Special Tips

- Special needs students may find this activity easier if the paper is precut

and the corners that are to be pinned are marked.

- Be sure students can work safely with the sharp pins.

Twirling Glider (p. 72)_____

Themes

- Biology: plant design and seed dispersal
- Physics: aerodynamics
- Social studies: Leonardo da Vinci and his world
- Art: paper folding, Leonardo da Vinci

Objectives

Students will:

- create a kinetic paper shape
- understand simple aerodynamics

Preparation

- Using heavier paper will negate the folding process.

Vortex (p. 73)_____

Themes

- Science: air mass, aerodynamics, lift, thrust
- History: early aviation
- Art: paper folding

Objectives

Students will:

- create a simple paper glider
- learn basic aerodynamic principles

Preparation

- Practice "the throw" in order to demonstrate it for students.

Special Tip

- Special needs students may find the activity itself easy but the throwing hard because of the motor skills involved.

Screamer (p. 74) _____

Theme

- Science: nature of sound
- Art: recycled materials craft

Objectives

Students will:

- explore sound and vibration
- have fun with sound

Preparation

- Collect corks. Cut into $\frac{1}{2}$" lengths and make a slit in each.

Special Tip

- This activity is not recommended for special needs students.

Twirling Colored Disks (p. 75) _____

Themes

- Science: inertia, laws of motion
- Social studies: Sir Isaac Newton
- Art: color mixing

Objectives

Students will:

- develop their understanding of color mixing
- improve motor coordination

Preparation

- To save time, provide 3" circle patterns for students to trace onto the poster board.

Special Tip

- Special needs students may find the activity itself easy but the execution of the motion difficult. For an easier version of color mixing, try the easier Spinning Top activity.

Spinning Top (p. 77) _____

Themes

- Science: gravity, center of gravity, centripetal force
- Social studies: Galileo, sixteenth- and seventeenth-century Italian scientific advances
- Art: color mixing

Objectives

Students will:

- develop their understanding of primary color mixing
- use fine motor skills

Preparation

- To save time you may wish to provide circle patterns for tracing or the actual circles, precut.

Jellyfish (p. 78) _____

Themes

- Science: ocean life, iridescence, jet propulsion

Objectives

Students will:

- develop observation skills

- develop understanding of movement

Special Tip

- Special needs students may need help separating the shelf paper from its backing. They also need to be told that once exposed and folded together the shelf paper cannot be reopened.

Ocean in a Jar *(p. 80)* _____

Themes

- Science: wave motion, ocean life, oil and water
- Art: kinetic art

Objectives

Students will:

- develop observation skills
- develop understanding of wave movement
- practice scenic design

Special Tips

- Special needs students will find this activity easy.
- Make sure the top of the jar is glued tightly.

Cartesian Diver *(p. 81)* _____

Themes

- Literature: *20,000 Leagues Under the Sea* by Jules Verne
- Science: air pressure versus water pressure, personal diving equipment, diving bells
- Medicine: the bends
- Art: creative object manipulation

Objectives

Students will:

- explore concepts of water pressure and air pressure
- make a historical toy

Special Tip

- Most special needs students will find this easy. Some may need help creating the diver. Others may not have the strength to press the top of the bottle hard enough to create the needed pressure. You may want to do this activity as a demonstration only with these students.

Glass-Bottle Barometer *(p. 82)* ____

Themes

- Science: air pressure, meteorology
- Math: measurement
- Language arts: story writing
- Art: creating with recycled materials

Objectives

Students will:

- create a scientific instrument
- gain an appreciation of the effects of barometric pressure

Special Tip

- Special needs students will find this activity difficult in concept and execution.

Palm Tree *(p. 84)* _____

Themes

- Social studies: tropical climates, human uses of palms
- Biology: palm species around the world
- Art: creating with recycled materials

Objectives

Students will:

- make a readily recognizable tree
- create a natural object from recycled materials

Stand-up Tree *(p. 85)* _____

Themes

- Biology: evergreens
- Social studies: the Christmas tree custom
- History: German Christmas customs
- Art: holiday craft object

Objectives

Students will:

- create a 3-dimensional object
- participate in a seasonal activity

Preparation

- Make enough copies of the pattern (p. 86) on tagboard for the whole class.

Special Tips

- Pretraced trees may make this activity easier for some special needs students.
- You may want to control placement of the staples.

Japanese Fan *(p. 87)* _____

Themes

- Social studies: Japanese art, use (especially social) of fans in history
- Art: watercolor, paper folding

Objectives

Students will:

- engage in creative design through 2-dimensional and 3-dimensional art experiences
- create a folded paper fan

Special Tip

- Special needs students should find this easy provided they have the motor skills to make the accordion folds. You will probably need to staple the parts together.

Paper Mask *(p. 88)* _____

Students may need help with finding facial features through the poster board or paper plate.

Themes

- Math: geometric shapes and designs
- Social studies: African cultures
- Art: African art, Pablo Picasso, Cubism

Objective

Students will:

- construct a mosaic design with natural materials

Special Tips

- Special needs students should be able to do to this activity easily provided the mask is precut.
- Some may have trouble handling the dried beans. Alternatively, they could paint or color the mask.

Marshmallow and Toothpick Ornament *(p. 89)* _____

Themes

- Math: geometric shapes

- History: early geometers (Pythagoras, Euclid, Plato, Aristotle)
- Chemistry: molecular structure
- Social studies/Holidays: Christmas ornaments
- Art: holiday craft object

Objective

Students will:

- create a 3-dimensional structure

Chinese New Year Mask *(p. 90)*___

Have students make up and act out stories using their masks.

Themes

- Social studies: Chinese customs, the Chinese calendar and zodiac
- Science: the lunar calendar
- Social studies/Holiday: New Year
- Art: creative design, cultural symbolism

Objectives

Students will:

- participate in the Chinese tradition of mask-making
- learn about China and its festivals

Treasure Pouch *(p. 91)* _____

Students can make an interesting "fabric" by crumbling or scrunching an 8" circle of heavy-duty brown shopping-bag paper (without logo) and opening it several times, rubbing with black or brown crayon when finished, if desired.

Themes

- Social studies: leather production, industry, and crafts, especially Spanish, in history
- Language arts: story writing
- Math: circumference, measurement
- Art: recycled materials

Objectives

Students will:

- create a useful item from material
- use lacing skills in making an object

Special Tips

- Special needs students would benefit from the fine motor skill exercise associated with the lacing of the pouch. The material may need to be pre-punched, and numbering the holes on alternate sides of the material may help them follow the lacing order correctly.
- They probably would enjoy making the brown paper "fabric."

Ojo de Dios *(p. 92)* _____

Themes

- Social studies: Mexican traditions, color symbolism
- Art: fiber arts

Objectives

Students will:

- learn about Mexican culture
- learn about symbolism in design and color use

Special Tip

- Special needs students will find this activity difficult.

Board Weaving with Yarn *(p. 93)* ___

Bring in examples of various types of weaving or pictures of the textiles of various cultures.

Themes

- Math: measuring inches
- Social studies: weaving through history, silk making and Chinese textiles, industrial revolution
- Art: color and design

Objectives

Students will:

- work with the concepts of over and under, warp and weft
- weave a useful object

Special Tip

- This is a difficult activity for special needs students. Gauge the individual student's ability with the various steps involved.

Natural Dye Eggs *(p. 96)* _____

Themes

- Social studies: spring celebrations, Easter traditions, egg symbolism
- Science: natural dyes, alternative dyeing techniques
- Art: fiber arts, natural dyeing

Objectives

Students will:

- participate in a seasonal/holiday activity
- use a natural dye source

Preparation

- You will need to have a hot plate on hand and have at least one saucepan heating at the beginning of the class. If using the "Additional Idea," have the other food materials and white vinegar on hand.

Special Tips

- Special needs students will find this activity exciting if they can tolerate the wait. (You could have them prepare another egg with an "Additional Idea" material in the meantime.)
- They will require close supervision around the boiling water.

Geodesic Shapes *(p. 97)* _____

Bring in pictures of geodesic dome buildings.

Themes

- Math: 3-dimensional shapes
- Art: architecture
- Social studies: R. Buckminster Fuller

Objectives

Students will:

- create a 3-dimensional form
- practice cutting and scoring

Preparation

- Make circle and triangle templates on oaktag for students to trace.

Special Tip

- Special needs students may find this activity difficult in concept and execution.

Creepy Crawly Critters (p. 98) ____

Themes

- Biology: spiders
- Holiday: Halloween
- Literature: *Charlotte's Web* by E. B. White, other children's books featuring spiders
- Art: seasonal craft

Objectives

Students will:

- learn about spiders
- create a seasonal item

Special Tip

- Special needs students may find this activity difficult because of the wrapping around the legs to make the body.

Indian Corn (p. 99) _____

Themes

- Science: cell division, selective breeding of crops
- Social studies/Holidays: early agriculture in North, Central, and South America, Thanksgiving
- History: Pilgrims and Indian aid in their survival
- Art: seasonal crafts

Objectives

Students will:

- create a seasonal object from paper
- learn about corn

Preparation

- Enlarge and photocopy the corn pattern onto heavy paper. Create the "kernels" from construction paper (a paper cutter would be helpful for this).

Dreidel (p. 100) _____

Themes

- Social studies: Jewish traditions
- Holiday: Hanukkah
- Science: centripetal force, tops
- Art: seasonal crafts

Objectives

Students will:

- create a seasonal item
- learn to play an ancient Jewish game

Preparation

- Photocopy the dreidel pattern onto heavy paper.

Special Tip

- Special needs students may find the construction of the dreidel difficult but will enjoy playing the game.

Pyramids and Polyhedrons

A *polyhedron* is a solid shape with flat sides. Pyramids are polyhedrons. When we think of pyramids we usually think of the pyramids of Egypt, but there are several different kinds of pyramids. Pyramids are classified by the shape of their base. Some have a triangular base. This kind of pyramid is called a *tetrahedron*. Many crystals with this shape are found in nature. Some pyramids—like the famous Egyptian pyramids—have a square base. The shape of the Egyptian pyramid had a certain meaning. It represented the mound on which the sun god stood at the beginning of time, when he brought all the other gods and goddesses into being. Many other cultures have also used the pyramid shape for their temples. The ancient Sumerians built their temples, called *ziggurats*, in a pyramid shape. So did the Aztecs in Mexico. Because the angles of the pyramid are hard to build, this shape is not common in buildings today. Still, the Louvre Museum in Paris, France and the Great American Pyramid in Memphis, Tennessee are both built in a pyramid shape.

Another polyhedron shape is the *hexahedron*. This shape has six sides; it is more commonly known as a cube. Unlike the pyramid, this shape is easy to build, and is often used in construction. This shape is often found in nature, too. Gems like diamonds and garnets have a hexahedral structure.

Materials

Polyhedron pattern (pyramid, tetrahedron, or cube)

Paper

Colored pencils *or* markers

Glue or glue stick *or* tape

Procedure

1. Cut out the pattern along the dotted lines.

2. Fold or crease along each solid line. (To get a perfect crease, score the line first. Hold a scissors so that the back edge of the blade touches the paper. Run the edge along the line. Don't press too hard, or the paper will tear.)

3. Fold the tabs inward along the solid lines.

4. Fold the solid lines the same way.

5. Glue each tab to the corresponding edge—Tab A to Edge A, Tab B to Edge B, etc.

Additional Idea

Decorate your polyhedron any way you want. On a square-based pyramid, try making Egyptian hieroglyphs, Aztec glyphs, or Mesopotamian motifs.

(continued)

Pyramids and Polyhedrons *(continued)*

Pattern: Pyramid with Square Base

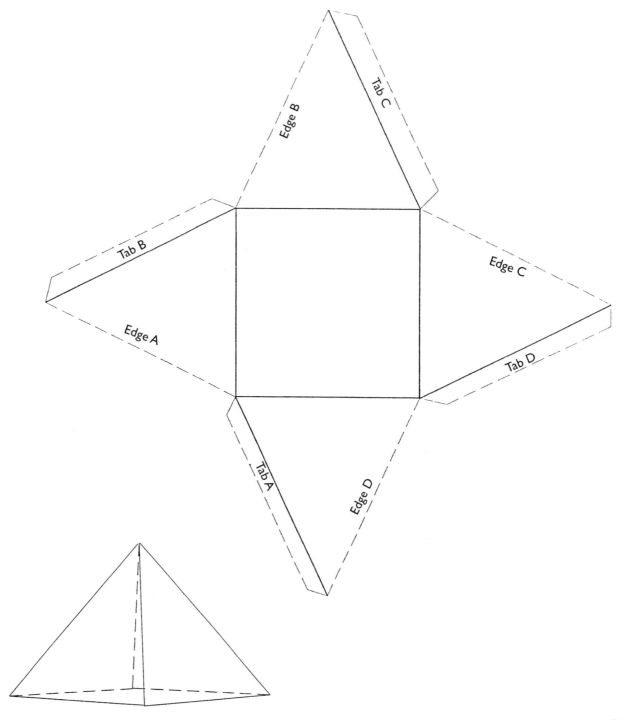

Making Connections: Interdisciplinary Art Activities

(continued)

Pyramids and Polyhedrons *(continued)*

Pattern: Tetrahedron (Pyramid with a Triangular Base)

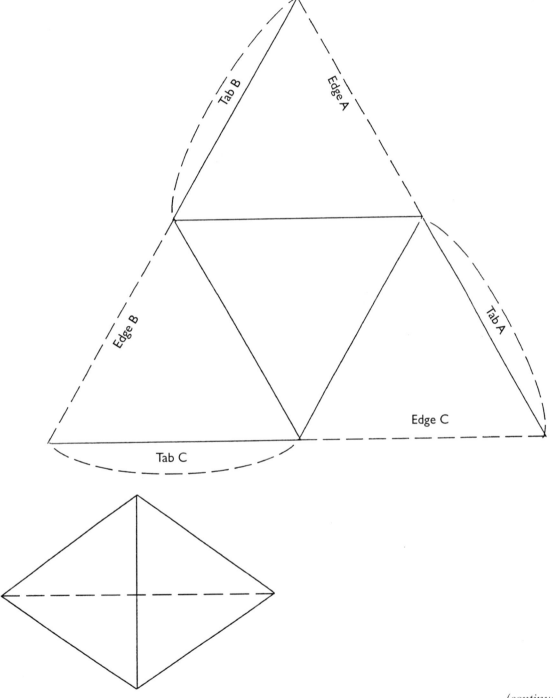

(continued)

Pyramids and Polyhedrons *(continued)*

Pattern: Hexahedron (cube)

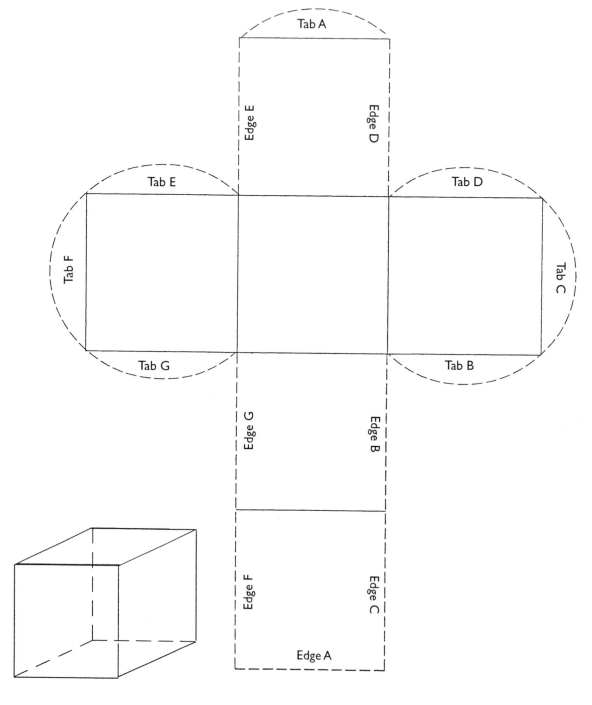

Making Connections: Interdisciplinary Art Activities

Paper Cup

Thirsty? Need something to put your newly discovered rock collection in? Or do you just want to see if this design will "hold water"? Here is a simple folding design that might come in handy someday.

Materials

8" square piece of paper (waxed paper works best)

Procedure

1. Fold the square on the diagonal.

2. Fold the left-hand corner to the middle of the opposite edge.

3. Do the same with the right corner.

4. Fold down one layer of the top triangle. Turn over and fold down the other layer.

5. Open up the cup and push in the bottom.

6. Try it—it really works!

Additional Idea

Write a story about using your <u>handy</u> paper cup!

Mobius Magic

These simple twists of paper are named after the German mathematician August F. Mobius (1790–1868). Once this strip of paper is twisted, taped, and cut it will create a larger circle of paper. If twisted and cut again the circle becomes even larger. Try to see how big you can make your mobius circle. The area the paper covers is the same, whether together in a mass or spread as far as it can go. Either way it seems like magic!

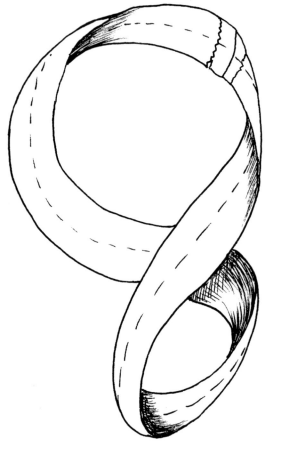

Materials

Tape

Ruler

Pencil

Scissors

3" × 12" (approximately) strip of paper

Procedure

1. Draw a line down the middle of the strip of paper.

2. Twist the paper once, twice, or three times, then tape the ends together.

3. Cut on the line drawn on the middle of the strip, including the taped portion.

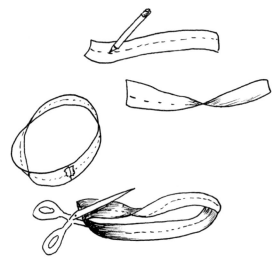

Spiral Breeze Catcher

Air movement is caused by the tendency of warm air to rise and cool air to sink. A spiral shape can easily catch any passing air currents because it catches air at most angles and leads it into an upward or a downward thrust.

Materials

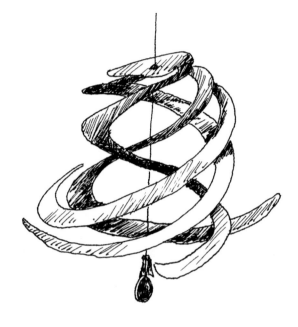

Colored construction paper

Pattern *or* compass and ruler

String

Glue

Scissors

Small weight (e.g., a brad or a paper clip)

Procedure

1. Use the pattern provided, making a small hole in the center. Cut around the outer circle, and along the solid lines to the inner circle. Do **not** cut along the inner circle.

2. Cut the spirals carefully.

3. Thread the string through the hole in the center.

4. Tie a knot in the string just under the hole so that the center is resting on the knot.

5. Tie a brad, paper clip, or something similar in weight to the lower end of the string.

6. Hang your breeze catcher where there are air currents and watch the spinning motion.

(continued)

Spiral Breeze Catcher *(continued)*

Additional Ideas

- Try suspending your spiral over a piece of black paper in the sunlight away from a lot of air movement. Does it spin faster or more slowly?

- Make the design on a piece of heavy-duty aluminum foil by placing the foil under a pattern of the spiral, then cutting out. Hold the finished foil spiral over a candle to observe how the warm air currents move the spiral.

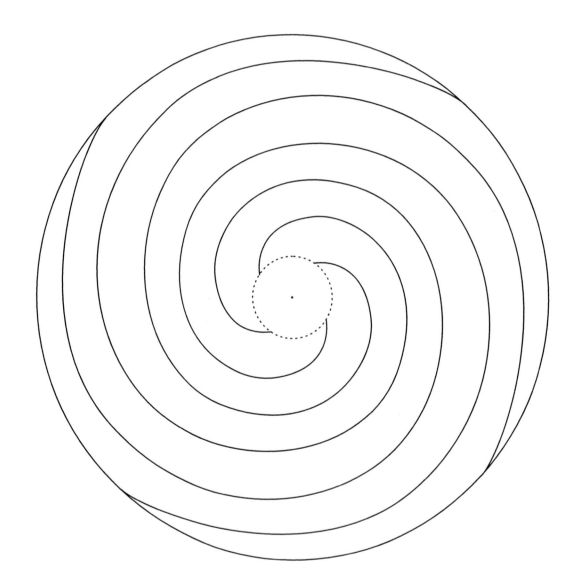

Making Connections: Interdisciplinary Art Activities

Name _____ Date _____

Pinwheel

People in the Netherlands have used wind for centuries to create power for grinding grain and—more recently—for generating electricity. Converting wind into mechanical energy is just part of the endless chain of energy being changed from one form to another. (Energy can never be created anew. Nor can it be destroyed! This is called the *law of conservation of energy*.) The pinwheel is a very basic design that uses paper to catch wind currents and thrust them upward to push a movable shape. The faster the wind is caught, the faster the speed of the turning pinwheel.

Materials

5" or 6" square of paper

Nickel or penny

Scissors

Pencil with eraser

Pin with a large head or thumbtack

Optional: quart milk carton, paint

Procedure

1. Fold the square of paper diagonally to each corner, creating an "x" design within the square when open.

2. Use a nickel or quarter to trace a circle in the center of the square.

3. Cut on diagonal folds *to the circle*—do not cut the center circle!

4. After all four diagonal creases are cut, lift every other point to the center of the square, spearing the points with the pin.

5. Push the pin through the center of the square into the pencil eraser. Be careful not to push so far as to expose the pin point.

Turn down

Name _____ Date _____

Twirling Gliders

The design of these simple gliders can be seen in the seeds of some trees. The design helps the seeds glide gently away from the tree to find a new place to settle and grow. The air holds them up and their shape makes them fly in different patterns. The artist and scientist Leonardo da Vinci (1452–1519) observed designs like this in nature. They were the basis for the idea he had to create a flying machine much like our helicopter.

Materials

4" × 11" strip of paper

Paper clip

Procedure

1. Fold the paper in half lengthwise.

2. Fold in half lengthwise again.

3. Fold in half widthwise.

4. Bend the top 1½"–2" of the ends as shown, at a slight diagonal. The ends should both point away from the body of the glider.

5. Weight the bottom with a paper clip.

6. Bend the paper outward slightly at the top of the paper clip.

7. Drop your glider from a high point to see it fly.

8. Make any needed adjustments after the first flight.

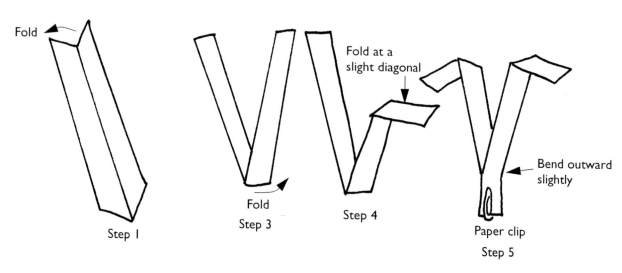

Fold — Step 1

Fold — Step 3

Fold at a slight diagonal — Step 4

Bend outward slightly

Paper clip — Step 5

Making Connections: Interdisciplinary Art Activities

Vortex

A *vortex* is defined as a whirling mass of air (or water). This powerful mass forms a vacuum in its center. Anything caught near this motion is drawn into it. Whirlpools and tornadoes are examples of this. When this principle is incorporated into the basic elements of flight (weight, lift, thrust, and drag), an interesting airplane design is achieved. Orville and Wilbur Wright, before achieving the first powered flight at Kitty Hawk, North Carolina, in 1903, used gliders in their early experiments. The principles of the vortex glider paper airplane design were used in an actual airplane named the *Aerodyne*.

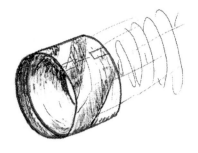

Materials

$4\frac{1}{2}$" × 11" inch piece of paper (copier paper is fine)

Ruler

Pencil

Tape

Markers

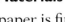

Procedure

1. Mark the paper with 4 lines $\frac{1}{2}$" apart, as shown.

2. Create an original design on the other side of the paper with the markers.

3. With the lined side of the paper up, fold along the first line.

4. Repeat folding until all four lines have been creased and folded over. This creates weight on the front of the glider.

5. Pull the two short ends of the paper together, overlapping the edges, then tape as shown.

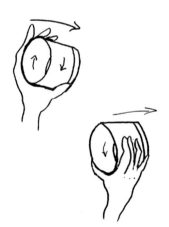

The Throw

To launch, hold the vortex gently around the front (the heavy end). Throw the glider briskly forward. Let it roll off your fingertips as you let go so that it spins like a football. Getting a good spin is important for a good flight. If your glider does not fly, add a little more tape to the front for weight. It is also important that your vortex is round, not warped. If all else fails, try again!

73 *Making Connections: Interdisciplinary Art Activities*

Screamer

Sounds are created from vibrating airwaves. The loudness of a sound depends on the amount of energy in the sound waves. Experiment with swinging your screamer with more force or less. Do you hear a change? This is called *resonance*. What else do you think would make a sound in this manner?

Materials

Index card (no smaller than 3" × 5")

Tongue depressor

String

2 corks, cut to $\frac{1}{2}$" length, and slit on one side

Rubber band

Procedure

1. Glue the index card to the tongue depressor as shown.

2. Place one end of the tongue depressor into the slit on the side of a cork.

3. Place the other end of the tongue depressor into the slit on the side of the other cork.

4. Trim the corners of the index card by degrees as shown. You can adjust the trimming of these edges after the rubber band and the string are put on. This should alter the sound of the screamer.

5. Wrap the rubber band around the top of the screamer, going around both corks.

6. Tie one end of the string around the tongue depressor.

7. Hold on tightly to the string. Swing the string briskly in a circle over your head, taking care not to hit anyone around you.

Caution: Be careful when swinging. Parts may break off if not fastened properly!

Step 1

Step 3

Step 4

Steps 5 and 6

Twirling Colored Disks

Sir Isaac Newton (1643–1727) was one of the greatest scientists of all time. He made important discoveries about physics, mathematics, and astronomy. These discoveries laid the foundation for modern science. His laws of motion are still used to understand the complexities of science.

The spinning disk in this activity illustrates one of Newton's laws. The motion of the disk winds the string so tightly that the energy takes the path of least resistance. It has to turn around and go the other way, repeating the momentum. The inertia of the twirling cardboard and the winding of the string absorb and release energy through the natural motion of twisting and pulling. This illustrates Newton's first law of motion. While the disk is twirling, the colors applied to the cardboard are blended visually. It is interesting to note the placement of the design and what it looks like at high speed as opposed to standing still.

Materials

Medium-strength white poster board

Scissors

String approximately 30" long (no yarn)

Colored markers

Compass

Procedure

1. Use a compass to draw a three-inch circle on the poster board. Cut out the circle.

2. Draw a line down the center of both sides of the disk (front and back).

3. Choose two primary colors (red, blue, or yellow). On one side of the disk, color one half one primary color and the other half a second primary color. Experiment with designs on the second side but limit your colors to <u>two</u>.

4. Make two holes about $\frac{1}{2}$ inch apart in the center of the disk.

5. Thread the string through the holes and tie the ends of the string together.

Step 2

Step 3

(continued)

75 *Making Connections: Interdisciplinary Art Activities*

Twirling Colored Disks *(continued)*

Operation

1. To operate the disk, place your thumbs in each end of the string and swing the disk in a circle to wind it.

2. Making sure the disk is upright, pull your hands apart or increase the distance between your hands. The disk will spin as the string winds. When you relax the string or bring your hands closer together the disk rewinds the string as it continues spinning. You can feel a slight change in the momentum that lets you know to pull or release.

3. Watch the different color changes as the disk spins. Watch out—it can be so hypnotic you won't want to quit!

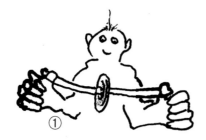
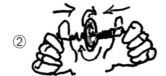
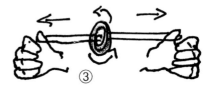

Name _____ Date _____

Spinning Top

The spinning of a simple top uses the complex theories of scientists such as Galileo (1564–1642). Galileo, an Italian, studied the way gravity affected objects. The spinning of a top produces a force that continuously pulls toward the center of the circle. This force is called *centripetal force*. The centripetal force allows the spinning top to find a center of gravity that lets the top spin on a very small point. When the top loses speed, the forces that create this gravity are lost and the top wobbles and falls.

Materials

Compass

White poster board

Toothpick

Red, yellow, and blue magic markers

Scissors

Pin or sharp point to poke a hole into the poster board

Clear tape

Procedure

1. Use a compass to draw a three-inch circle on the poster board. Mark the center point of the circle. Create an original design within the circle. Use only two of the primary colors—red, yellow, and blue. Decorate both sides if desired.

2. Cut out the circle, make a small pinhole in the center, and insert the toothpick into the hole. If the toothpick does not fit the pinhole snugly, place a piece of tape over the hole and put the toothpick through again.

3. Grasp the toothpick at the top with the thumb and index finger, place on a flat surface, and twirl. What happens to the colors on the top as it spins?

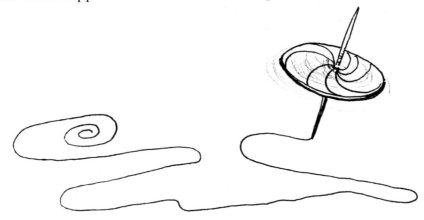

Jellyfish

The jellyfish is mostly an ocean creature but can be found at times in fresh waters. It is typically shaped like a bell or inverted bowl. Within the jellylike bell area, the jellyfish has small sense organs that respond to light and gravity. Along the base of the bell are tentacles. These are organs that sting and paralyze plankton, small fish, or even other jellyfish. The catch is then moved to a mouth at the center of the bell. Many species of jellyfish have four oral arms around the mouth to help it eat. The jellyfish seem to dance gracefully through the ocean waters, but in fact many use jet propulsion to move by expelling water through the bell and out. Jellyfish can be a nuisance to swimmers in coastal areas. Some barely make a mark when they touch a person, while other species can deliver a fatal sting.

Materials

6" × 10" piece of clear adhesive shelf paper

$\frac{1}{4}$" strips of pastel tissue paper (pink, blue, white, yellow, green) *or* iridescent wrap or ribbon, shredded

Pen

Scissors

Hole punch

String

Optional: petroleum jelly

$\frac{1}{2}$" strips of waxed paper 12" to 18" long *or* iridescent wrap or ribbon

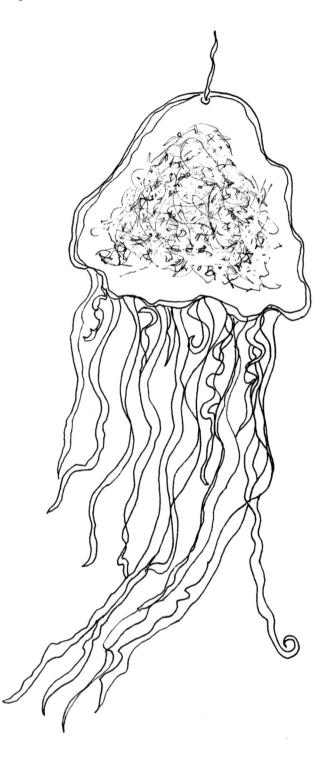

(continued)

Jellyfish *(continued)*

Procedure

1. Fold the 6" × 10" shelf paper in half lengthwise. Draw and cut out a jellyfish shape.

2. Peel the paper apart, exposing the sticky part.

3. Put a few strips of tissue paper in the middle of the jellyfish shape. (Add petroleum jelly if desired.)

4. Add tentacles made from waxed paper strips to the bottom of the shape. (Add small strips of the tissue paper if desired.)

5. Fold both halves of the shelf paper together to seal.

6. Punch a hole in the top, then hang.

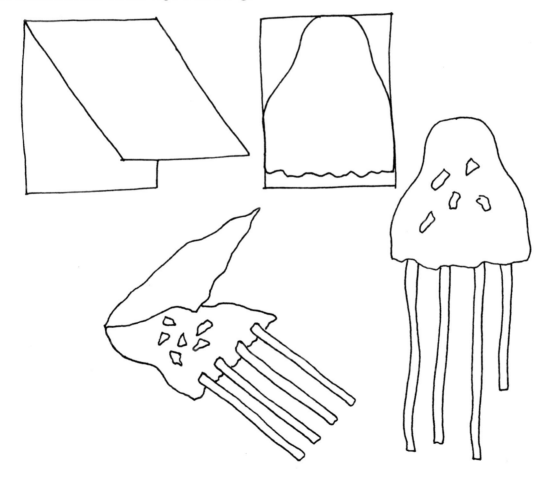

Name _____ Date _____

Ocean in a Jar

Movement is created by *kinetic* energy. Kinetic art is a type of art with movement. Most kinetic art pieces rely on scientific principles such as those behind wind, electricity, or computer science to provide the basis for the art concept. A wave in a jar can provide fascinating viewing and experimentation. Waves can be created by slowly tilting the container back and forth. If you stop moving the jar back and forth the motion inside the jar keeps going. Why? The fact that the mineral oil and the colored water do not mix makes this experiment possible. Why don't they mix?

Materials

Clear plastic container or glass jar with top

Mineral oil or clear cooking oil

Blue food coloring

Water

Procedure

1. Fill the container halfway with water and add several drops of blue food coloring.

2. Fill the container the rest of the way with mineral oil.

3. Pour rubber cement into the cap of the container.

4. Screw the cap on, wiping off the excess rubber cement. Allow it to dry before use.

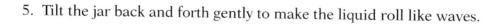

5. Tilt the jar back and forth gently to make the liquid roll like waves.

 Making Connections: Interdisciplinary Art Activities

Cartesian Diver

This tiny, easy-to-make aluminum diver was developed as a scientific experiment. It was used by the seventeenth-century French philosopher, scientist, and mathematician René Descartes (1596–1650). The diver floats because of the air bubbles trapped in the head. Because water is not compressible, it can be used to create pressure to move air in a tight space. When you place your thumb on top of the bottle, water is forced into the head, making the trapped air bubbles smaller. When you release your thumb, the compressed air bubbles become larger and force the water out of the head. Try to control the rise and fall of your diver.

Materials

$\frac{1}{2}$" × 6" strip of aluminum foil

Scissors

Narrow-necked bottle (such as a soda bottle)

Water

Procedure

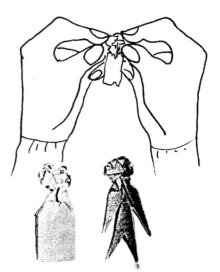

1. Very carefully pinch and shape 5 inches of the foil into a *loose* ball, which will be the diver's head. This will make the diver float.

2. Snip away small pieces from the remaining inch of foil to create the diver's body.

3. Put the diver into a bottle filled to the brim with water. If necessary, add more water to the bottle so that there is a little hill of water above the opening.

4. Place your thumb over the bottle top *so that **no** outside air is trapped under it.*

5. Press down, and the diver starts sinking. Continuous pressure will make the diver sink. Release the pressure, and the diver floats to the surface. (If your diver does not float, there may not be enough trapped air in the head. Try making another diver, this time keeping it looser.)

81 *Making Connections: Interdisciplinary Art Activities*

Glass Bottle Barometer

The level of the water in a tube will move up and down in response to air pressure. Air pressure pushes us from all sides. During various weather conditions the air pressure increases or decreases. To measure it we use an instrument called a barometer to find barometric pressure. It is possible to make weather predictions simply by observing whether the barometric pressure is increasing or decreasing. When the air pressure drops, the water level in the barometer rises. When the air pressure rises, the water level drops. Falling pressure means stormy weather is on its way; rising pressure means good weather. In the old days sailors worried if they saw that their barometer's fluid level was falling fast. Why might this have worried them? Write a story about a sea voyage involving a barometer.

Materials

Glass bottle, pint size or larger, with screw cap

Big nail (tenpenny size)

Paper cup

8" length of clear flexible tubing

Food coloring

Rubber cement

Water

Clear tape

Medicine dropper

Mineral oil *or* cooking oil

Blank paper

Pen

Colored markers

Scissors

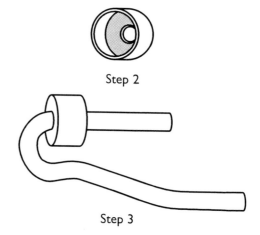

Step 2

Step 3

Procedure

1. Make a hole in the side of the paper cup large enough for the tubing.

2. Punch a hole through the bottle cap with the nail. Enlarge it so that the end of the tube will fit snugly in the hole.

3. Insert the tube into the hole. About three inches should go to the inside of the cap, with five inches left outside.

4. Fill the glass bottle ½ full of water. Add food coloring to get an intense color that can be easily seen.

(continued)

Glass Bottle Barometer *(continued)*

5. Apply rubber cement generously to the inside of the bottle cap and the neck of the bottle. Use plenty of cement or the completed barometer will drip at this joint.

6. Screw on bottle-cap-and-tube assembly. Add another coat of rubber cement at the junction to catch any leaks.

7. Slip the paper cup onto the bottle so that the rim of the cup rests on the "shoulders" of the bottle. Run the tubing through the hole in the side of the cup.

8. Tape the tube loosely to the side of the bottle, open end down.

9. Take the water-filled bottle to the sink. Place a finger over the open end of the tube and turn the bottle upside down. Remove your finger from the end of the tube and allow the water to flow out of the end, if it will.

10. Set the completed barometer on its paper cup holder, taking care that the tube is not kinked or closed off by the weight of the bottle of water.

11. Using a medicine dropper, place two or three drops of mineral oil or cooking oil in the end of the tube. (This slows the evaporation of the water in the barometer.)

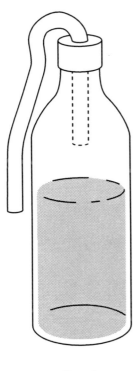

Step 6

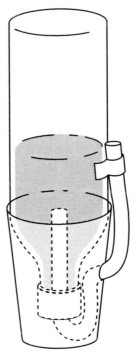

Step 10

Name _____ Date _____

Palm Tree

Among the easiest to identify, the trees of the palm family are found in the tropical and subtropical regions of the world. The palm family contains some of the oldest flowering plants known. Fossil records of palm trees and their ancient relatives have been found as far back as the Triassic period, that is, about 220 million years ago! There are a wide variety of palm trees in the world (nearly 2,500 species). Each one has adapted nicely to its individual surroundings.

Humans have adapted nicely to the palm as well. Palm trees have provided food and drink, shelter, clothing, fibers for weaving, building materials, and waxes and oils. People of tropical Asia sometimes chew the fruit of the betel palm as a stimulant. The camel driver getting ready for a trek into the Sahara Desert never forgets to bring dates from the African date palm. And, what would sunscreen be without coconut oil? What other uses can you think of for *your* palm tree?

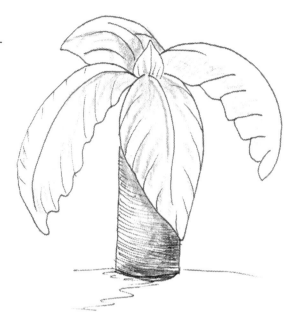

Materials

Cardboard tubes (paper towel tubes work well)

Green construction paper (12" × 18")

Scissors

Glue

Procedure

1. Cut the construction paper in the form of a large leaf. Use the pattern if you wish. Cut slits in the leaf at angles going down the sides of the leaf. Remember, there is a wide variety of palm leaves.

2. Fold the leaf near the stem, as indicated on the pattern. Glue the stem of the leaf into one end of the cardboard tube. Bend the leaf so that it droops slightly.

3. Make several leaves this way so that the palm tree will look full.

4. You may also color the cardboard tube brown or draw lines on it to resemble a palm tree's texture.

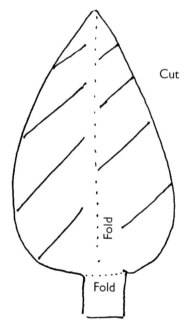

84 *Making Connections: Interdisciplinary Art Activities*

Stand-up Tree

The Christmas tree is a German custom. English lands adopted it after Queen Victoria married a German prince. The evergreen symbolizes the celebration of life in the midst of winter when nature seems dead. The evergreen is important ecologically because it continues to clean the air and give off oxygen during the winter. The tree illustrated here is a Christmas tree, but don't stop there . . . trees come in many varieties. Try some others with a sturdy base or with grass at the base to help them stand. How do we use trees in our everyday lives?

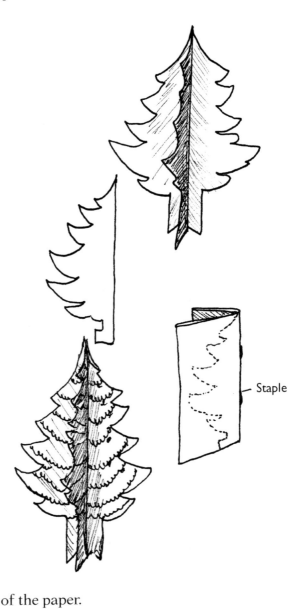

Staple

Materials

Tree pattern

Green construction paper (6" × 9")

Pencil

Scissors

Stapler

Markers

Optional: glitter *or* tissue paper and glue

Procedure

1. Take 2 or more 6" × 9" pieces of construction paper.

2. Fold the paper in half lengthwise. The result is a 3" × 9" piece.

3. Trace the tagboard tree shape onto the construction paper. The straight edge of the tree should be on the folded edge of the paper.

4. Cut the shape out. Do **not** cut along the folded edge.

5. Staple the tree shapes together with 2–3 staples on the mid-crease. Open out to make tree stand.

Additional Ideas

For Christmas trees, decorate by coloring ornaments directly onto the paper; rolling small pieces of tissue paper into balls, then gluing on; using stick-on stars; pasting on colorful fallout from a hole punch; or using glitter and glue.

85 *Making Connections: Interdisciplinary Art Activities*

Stand-up Tree *(continued)*

Tree Pattern

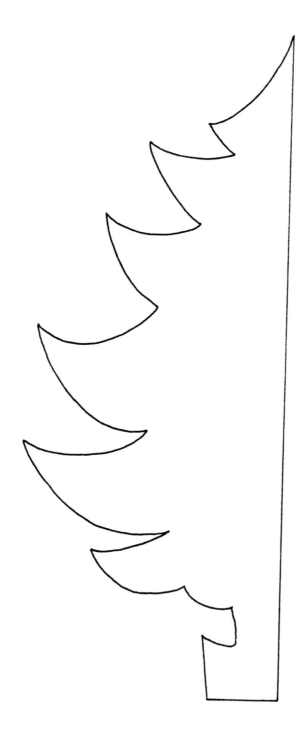

Name _____ Date _____

Japanese Fan

Handheld fans have long been popular in many countries around the world. Each country had its styles and decorations, but the Japanese excelled in the beauty and simplicity of their scenes and designs. As a matter of fact, the folding fan is a seventh-century Japanese invention! It was first designed as a pleated, decorated leaf of paper mounted to a framework of thin sticks that radiated or "fanned" out. This fan design finally made its way to Europe around the fourteenth century. From behind a fan the world was an intriguing place. Books were even written to teach the "language of the fan." Can you imagine what *your* fan is able to say?

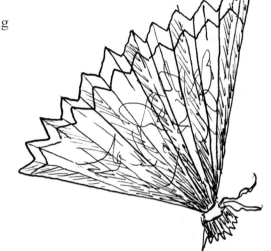

Materials

Stapler

Gold or red cord

12" × 18" white paper

Watercolor paints or markers

Gold foil wrapping paper in $\frac{1}{2}$" × 18" strips

Procedure

1. Glue a $\frac{1}{2}$" strip of gold foil paper across the top of the 12" × 18" paper.

2. Draw or paint a scene on the paper.

3. Starting at one edge, fold in vertical accordion pleats to the end of the paper.

4. Staple the folds together about $1\frac{1}{2}$" above the *non-foiled* end.

5. Spread the fan.

6. Wrap the cord around the base, and knot at the end.

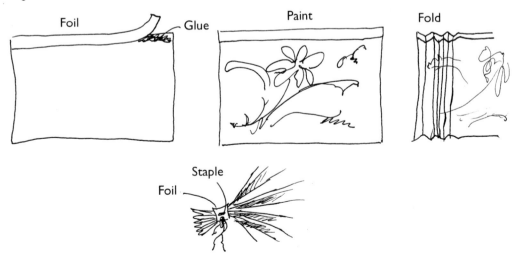

87 *Making Connections: Interdisciplinary Art Activities*

Name _____ Date _____

Paper Mask

Masks have played an important part in human history. All cultures in ancient societies used special masks to tell stories and frighten enemies. The masks of African cultures were especially expressive. The design of each mask had special meaning. The Dogon people of Mali used the spiral to represent nature and the triangle to characterize culture. Masks like the Senufo "firespitter" of the Ivory Coast were intended to purify an area by literally fighting fire with fire. The masks were created with materials found in nature such as wood, raffia, ivory, and metals, depending on the wealth of the region. The powerful shapes used in these masks have had enormous influence on the art of the twentieth century. The artist Pablo Picasso was particularly influenced by the geometric designs of African art and used them extensively in his work. What other cultures have a distinctive mask-making tradition?

Materials

String

Hole punch

Markers

Stick

White glue

Construction paper scraps

Various types of dried beans *or* uncooked macaroni

One 9" round piece of poster board *or* a paper plate

Optional: feathers

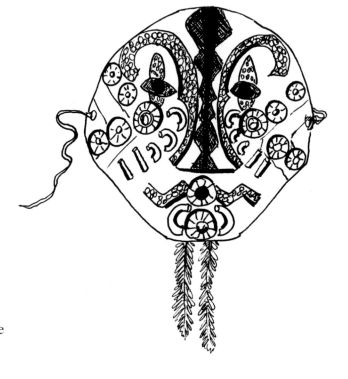

Procedure

1. Place the round shape on a partner's face.

2. By feel or estimation, mark where the eyes, nose, and mouth are located. Trade places and do the same for your partner.

3. Cut away openings for these marks.

4. Cut the openings into geometric shapes.

5. Decorate the mask shapes with special designs of your own.

6. Glue onto a stick *or* punch holes on each side to tie string.

Marshmallow and Toothpick Ornament

Around 540 B.C., the Greek mathematician Pythagoras of Samos tried to explain all aspects of the universe in terms of numbers. He presented the numbers as geometric shapes. Later, thinkers such as Plato, Aristotle, and especially Euclid used geometry heavily in their works. The word *geometry* is derived from the Greek words for "earth" and "measure." People had been creating geometric order out of chaotic shapes more than 14,000 years before the Greeks named this area of knowledge. With this activity, the modern study of mathematical theory has been vastly improved . . . you can eat your mistakes!

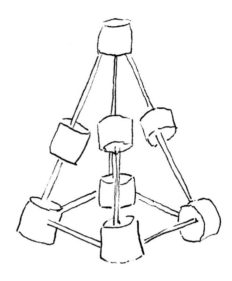

Materials

Marshmallows

Colored toothpicks

String *or* yarn

Procedure

1. Stick the toothpicks into the marshmallows. Form a structure using the marshmallows as joints between the toothpicks.

2. Let your structure sit overnight. Once the marshmallows harden, they will make firm, permanent joints, and you will be able to hang your ornament with string.

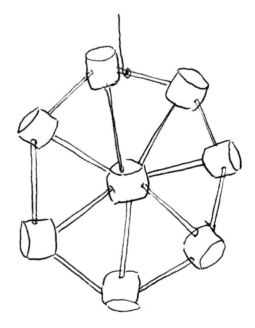

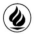

Chinese New Year Mask

The Chinese calendar is based on the lunar year, which is 354 days long. Each Chinese lunar year has a name. The year 1990, for instance, was the year of the horse. The next year was called the year of the sheep. The years after that in order are called the year of the monkey, the rooster, the dog, the pig, the rat, the ox, the tiger, the rabbit, the dragon, and the snake. Each year has its own special characteristics. Find out under which animal sign you were born. During the New Year celebration, there are great festivals, lots of fireworks, and parades with dragons that can take 12 people to move them around the streets.

Chinese New Year falls between January 21 and February 19, depending on the cycles of the moon.

Materials

Paper plate

Glue

Popsicle™ stick

Markers

Yarn

Scissors

Hole punch

Procedure

1. Glue the popsicle stick to the edge of the upper side of the paper plate.

2. Mark places for eyeholes on the paper plate.

3. Cut out the eyeholes.

4. Decorate the bottom side of the paper plate with markers or bright cut-paper shapes.

5. Punch a hole on each side of the paper plate.

6. Tie yarn through the holes for decoration.

Treasure Pouch

People have always needed something to carry their small treasures. Bags like these were originally made from leather and worn hanging from a belt. Areas known for their leather production are Spain, Argentina, and the United States. Historically, Spanish leather works were of high quality and much sought after.

Materials

Cloth or leatherlike material cut into an 8" circle

24" long string or shoelace

Hole punch (preferably $\frac{1}{8}$")

Procedure

1. In a circle about $\frac{1}{2}$" from the edge of the cloth, punch 19 to 21 holes. (It may help to punch the holes one quarter of the circumference at a time. Notice there are an uneven number of holes to be made. This is so the string will begin and end on the same side of the material.)

2. Thread the string through the holes all the way around the pouch. Bring the string back through the same hole you began on.

3. Knot the string ends. Pull the ends to close the pouch.

Additional Ideas

• Add beads to the string if desired.

• Be creative with your bag. Imagine what your pouch contained or contains, to whom it belonged, where it has traveled. Write about the story of *your* treasure pouch.

Name _____ Date _____

Ojo de Dios (God's Eye)

"God's eyes" are made in Mexico for good luck. Mexican children are often given these to celebrate the number of years old they are. Each color symbolizes a different year. (Try to say how old you are in Spanish!)

This tradition comes from the Huichol (WEE-chohl) people of western Mexico. The colors of the yarn in their designs had special meaning too. The center of the design was black to represent the pupil (center) of the eye. The color blue was used to represent a prayer to the sun god. The designs were usually made out of bright colors, and mirrors (or shiny objects) were added to help the god see.

Materials

Yarn (various colors) totaling two feet or more

Two sticks (dowels, ice cream sticks, straight branches)

Glue *or* tape

Scissors

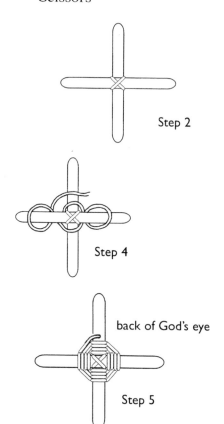

Step 2

Step 4

back of God's eye

Step 5

Procedure

1. Place the sticks together in a cross shape, intersecting in the middle. Glue or tape to attach the cross securely.

2. Tie one end of the yarn to the center of the cross.

3. Hold the sticks in your left hand. (Reverse these directions if you are left-handed.)

4. Take the yarn in your right hand. Bring it around the front of the top stick and behind the right stick, then around the right stick and in front of the bottom stick, making a figure eight around the sticks. Pull the yarn tight against the sticks.

5. When you reach the end of a length of yarn, glue the end to the back of one of the sticks. Glue the beginning of the next strand beside it, and continue.

6. Continue winding until the sticks are completely covered. Glue down the end of the yarn.

 Making Connections: Interdisciplinary Art Activities

Board Weaving with Yarn

Weaving has one basic concept: over and under. The *weft,* which is the thread with which you are weaving, is woven over and under the *warp,* or lengthwise threads.

Weaving has been used since the earliest civilizations. The Egyptians were excellent weavers. They used animal wool and hair, natural fibers from plants, leather, even silver and gold. The Chinese discovered silk. For thousands of years, they kept their secret of how to get hundreds of yards of silk from one tiny silkworm to weave the finest cloth. Later silk was exported by traders for very rich Europeans.

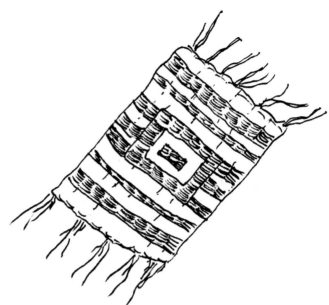

The Inca and Aztec Indians were known for their fine handwoven goods. Native Americans of the western United States are well known for their woven blankets and baskets. Both North and South American peoples often weave in geometric patterns using squares, rectangles, and triangles in their basic design form.

At first, all fabrics were handwoven on some sort of loom. As time went on, looms became larger and more complex. When the industrial age introduced mechanized looms, people could weave thousands of yards of cloth in the time it took to weave one blanket by hand. Today the textile industry is growing more advanced as new technologies become available. But hand weaving is still practiced as a craft—and as an art.

Materials

Cardboard, 6" × 10" or larger

Yarn *or* ribbon

Scissors *or* blade

Ruler

Tapestry needles *or* small cardboard shuttle

(continued)

Board Weaving with Yarn *(continued)*

Procedure to Make a Board Loom

1. Cut a sturdy piece of cardboard to the size needed.

2. Mark the places on each end about $1/2$" apart where you will cut a row of $1/4$" slits to hold the warp string.

3. Draw a design on your board. (Not required.)

4. Cut the marks on both ends about $1/2$" deep with a blade or scissors.

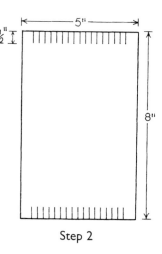

Step 2

5. String your *warp* on one side by looping the warp yarn around every other tab, alternating between the top and the bottom of the board.

Procedure to Weave

6. Pass the *weft* in and out of the warp strings with a needle or a shuttle that holds a quantity of string or weaving material. When one row has been woven, repeat the process, going in the opposite direction. Don't pull the string too tight, or the weaving will bow in. If you want to change yarn colors or textures or you run out of yarn, just tie more yarn on the end and continue weaving.

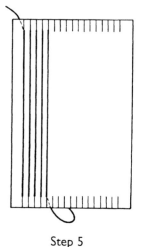

Step 5

Step 6

(continued)

Board Weaving with Yarn *(continued)*

7. After weaving a row, "pack" your yarn down by pushing down the row just woven. Packing your yarn makes your weaving tight—but packing too hard will make the weaving sag in the middle.

8. To create a design or pattern in the weaving, simply interlock the weft when one design or color stops and the other begins.

9. Stop weaving when you are one inch from the top of your "loom." To remove the weaving from the board, just bend the tabs down and slip off the loops.

Step 10

10. Tie the warp threads together in pairs to finish off your weaving.

Additional Ideas

• Study the textiles of other countries.

• Experiment by adding other materials to your weaving: raffia, grass, feathers, tissue paper, etc.

• Make a pencil holder: From the top edge, cut a plastic cup into strips, stopping 1" from the bottom. Weave yarn in and out of the strips until you reach the top. Try to incorporate a design in your weaving.

Name _____ Date _____

Natural Dye Eggs

Eggs have always had special meaning for people. When an egg hatches it reveals new life inside. To the ancients this became a symbol of the earth being reborn. Many cultures used the egg in their celebration of spring. The early Egyptians believed the mythical lotus flower of creation contained a golden egg that was the source of all life. They painted eggs in celebration of spring. The egg became connected with Easter when Christianity spread to Egypt in the first century A.D. All over the world, eggs are dyed in special ways and given for luck and prosperity for the coming year.

Materials

Eggs (to be boiled)

Yellow or red onions

Cheesecloth *or* muslin (any thin cloth that will withstand boiling), approximately 6" × 6"

Rubber bands

Water enough to cover the eggs, in a pot

Procedure

1. After peeling the skins from an onion, wrap them gently around an egg.

2. Place the egg on the cloth square and wrap the cloth around the onionskin-covered egg.

3. Gently put the rubber bands around the wrapped egg. (One or two should do it.) Be careful not to wrap the rubber bands too tightly . . . a broken egg is a mess!

4. Place the wrapped egg into the boiling water for about 15 minutes. (No 3-minute egg here!) Take the pot off the burner and turn off the heat. Let the egg steep in the water until it is fairly cool.

5. Unwrap the egg to see what interesting natural designs and colors have appeared. Yes, they are very edible after this, and they don't even taste like onion!

Additional Idea

Try using other natural dyes to dye the eggs. Experiment! Wrap the eggs as above. Add a couple of teaspoons of white vinegar to the cooking juices of fresh or frozen blueberries, shredded beets, frozen spinach, red cabbage, or strong tea or coffee.

Making Connections: Interdisciplinary Art Activities

Geodesic Shapes

In 1947, American inventor R. Buckminster Fuller patented a dome design. He called it a *geodesic* dome. This new dome design was structurally efficient. It could enclose a large area without needing any internal supports. Geodesic domes can be made by interlocking shapes like this one. These shapes are found in many designs in nature. See how many you can find.

Materials

Glue

Pencil

Scissors

Construction paper

Compass

Ruler

Procedure

1. Draw and cut 4, 8, or 12 three-inch circles.

2. Draw a triangle inside each circle so it touches the edges of a circle in three places. Draw a triangle lightly or trace the triangle shape.

3. Crease along the sides of the triangle. Fold the tabs up.

4. Glue the rounded tabs of two pieces together at a time. Be sure the edge of each fold is touching the other correctly.

5. Repeat with the other circles, two at a time.

6. How many circles can you connect in this way?

Additional Idea

• Your designs may be decorated and hung like ornaments with paper clips. To create a holiday ornament, try using wrapping papers or old Christmas cards to make the design. Or, put a photo in each triangular area.

Name _____ Date _____

Creeping Crawly Critters

Spiders are not insects! Spiders have eight legs, not six. (All insects have six legs.) Most people think spiders are creepy because they have long legs and we never know where they are to be found. In fact, spiders are a help to people because they catch pesky insects in their webs and eat them. Read a story about a spider, or try to find 10 spider facts.

Materials

4 black pipe cleaners (12" or 6" size)

1 yard black string per spider *or* colored string to copy the coloration of a real spider

Materials for eyes, such as sequins or small buttons

Glue

Optional: light-colored thread for the spider's line

Procedure

1. Crisscross the four pipe cleaners. Tie them together in the middle with the end of the yarn.

2. Wrap the yarn around the middle of the pipe cleaners, alternating in between the "legs" to create a "body." Tie off.

3. Use any extra string for the line *or* use light-colored thread.

4. Bend the pipe cleaners to make knee joints and feet.

5. Make eyes from colored sequins, small buttons, or the movable eyes available at a craft store. Glue onto the body.

Making Connections: Interdisciplinary Art Activities

Indian Corn

Corn has been a very important food crop throughout history in the Western Hemisphere. The ancient cultures of the western United States and Central and South America saw corn, or *maize*, as one of the most important things in their societies. Native Americans introduced the early Pilgrims to corn, which helped them survive in the colonies. This is one reason we use corn in Thanksgiving celebrations.

The ancient strains of corn were not the large, perfect ears we see today. It has only been through years of cross-pollination and selective planting that we have created the "perfect" ear of corn. Ancient varieties of corn were smaller and harder.

All corn has an even number of rows on the cob. This is a good example of how cells divide evenly.

Materials

Scissors

Pencil

Glue

Tagboard corn pattern

Construction paper in yellow, tan, or other light earth colors

Construction paper of various colors, cut into $\frac{1}{4}$" to $\frac{1}{2}$" squares

Procedure

1. Trace the corn pattern onto two or three pieces of earth-tone construction paper. Cut out the corn shapes.

2. On one piece, glue the multicolored bits of paper to look like kernels of corn.

3. Cut the other construction paper shapes down the middle to create the corn husks. (Leave the bottom third uncut.)

4. Glue the bottom third of the husk pieces over the bottom of the multicolored piece.

5. Fold the tops of the "husks" back to reveal the corn.

Dreidel

In the month of December the Jewish celebration of *Hanukkah* takes place. This festival is to celebrate the rededication of the ancient temple in the city of Jerusalem.

On a candlestick called a *menorah* one candle is lit on each of Hanukkah's eight days of celebration and thanksgiving. The ninth candle, in the center of the menorah, is used to light the other candles. The *dreidel* is a kind of top. It is used to play a game during this holiday season. Try not to lose all of your *gelt* (money)!

Materials

Dreidel pattern

Sharpened pencil

Gelt (gold-foil-covered chocolate coins) *or* tokens, coins, or chips

Glue or tape

Bowl

Procedure

1. Cut the dreidel pattern along the *dotted* lines.

2. Fold along the *solid* lines.

3. Glue or tape the shaded areas so that the tabs meet. (Fit tab A to A, B to B, C to C, etc.)

4. Cut off the bottom and top points and fit the pencil through, point down.

5. To make the dreidel spin in balance, experiment with moving the pencil up or down.

6. To play: Two or more people can play. Have each person start with the same number of coins.

7. Place a bowl in the center of the playing area.

8. Take turns spinning the dreidel.

9. When the dreidel stops, follow the directions on the side facing up. Take coins out of or put coins into the bowl.

10. Keep playing until one player has all of the coins. That person is the winner!

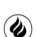

100 *Making Connections: Interdisciplinary Art Activities*

Dreidel (continued)

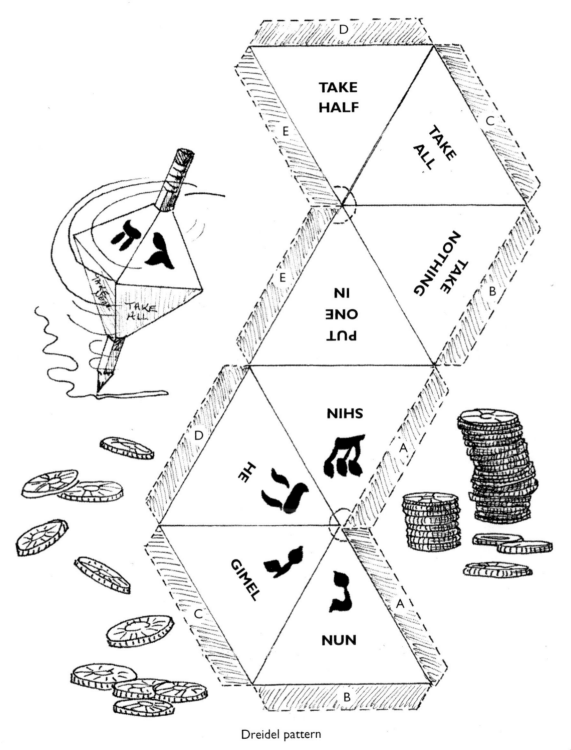

Dreidel pattern

Musical Things

Concepts from the simplest to the most abstract may be expressed through music. Rhythm and sound are second nature to humankind. The making of musical things is a good opportunity to teach about vibrations, sound waves, the ear and how its nerves transmit sounds to the brain, and sound perception. The kazoo works in much the same way as the eardrum. The shoebox banjo and not-so-French horn make sounds much the same way our vocal chords do. Children are especially fond of music and enjoy making their own instruments. For any of the following activities, you might wish to bring in an actual instrument for the students to examine or play recordings of the instrument and talk about the history of the instrument.

Kazoo (p. 105) _____

Theme

- Science: the workings of the eardrum
- Art: creating with recycled materials

Objectives

Students will:

- create a musical instrument
- experience sound through the use of simple objects

Rhythm Shaker (p. 106) _____

Theme

- Music: rhythm, rhythmic movement
- Art: creating with recycled materials

Objectives

Students will:

- create a percussion instrument
- experience sound through the use of simple objects

Preparation

- Collect (and ask students to collect) 12-ounce aluminum soft drink cans

Not-So-French Horn (p. 107) _____

Garden hose does nicely for this activity.

Themes

- Science: sound production by vibrating membranes, vocal cords
- Music: real French horn and other brass instruments, how pitch is related to length of tubing, which can be varied using crooks
- Art: creating with recycled materials

Objectives

Students will:

- create a wind instrument
- experience sound through the use of simple objects

Special Tip

- Special needs students may find this activity difficult.

Shoebox Banjo (p. 108) _____

Themes

- Science: sound vibration, tension
- Music: stringed instruments, production of sound through vibration
- Art: creating with recycled materials

Objectives

Students will:

- create a stringed instrument
- experience sound through the use of simple objects

Special Tip

- Special needs students may find this activity difficult but may enjoy the process and the outcome.

Panpipes *(p. 109)* _____

Themes

- Math: measuring lengths for pitch
- Social studies: Greek mythology
- Music: sound production in wind instruments

Objectives

Students will:

- create a woodwind instrument
- experience sound through the use of simple objects

Special Tip

- Special needs students may find the precision called for by this activity difficult to manage.

Maraca *(p. 110)* _____

Themes

- Social studies: use of seed gourds for musical instruments, Latin American and African musical styles

- Art: creating with recycled materials

Objectives

Students will:

- create a percussion instrument
- experience sound through the use of simple objects
- work with alternative art materials

Special Tip

- This activity is not recommended for special needs students owing to the feel of the wheat paste and the involved nature of the many steps.

South American Rain Stick *(p. 111)* _____

Themes

- Biology: ocotillo cactus
- Social studies: South American culture
- Art: creating with recycled materials

Objectives

Students will:

- create a musical instrument with recycled materials
- experience sound through the use of simple objects
- investigate South American culture

Special Tip

- This activity is not recommended for special needs students because of the pins. Gauge individual students' abilities to handle sharp objects.

Kazoo

Materials

Cardboard tube from a roll of toilet paper or paper towels

Waxed paper square (approximately 5" × 5")

Rubber band

Colored markers or acrylic paints

Procedure

1. Decorate the tube with markers or paints.

2. Cover one end of the tube with waxed paper.

3. Put the rubber band around the waxed paper at the end of the tube.

4. Pull the ends of the waxed paper until it is stretched tightly across the tube opening.

5. Pucker your lips and put them into the opening of the kazoo.

6. Hum or sing a tune.

Rhythm Shaker

Materials

Empty 12-ounce aluminum drink can

Small stones, unpopped popcorn, dried beans, or other noisemaking materials

Strapping tape or duct tape

Procedure

1. Fill the can with about $\frac{1}{4}$ cup of the noisemaking ingredients.

2. Tape the hole with strong tape.

3. Get into the rhythm of things!

Additional Idea

- To decorate the outside of the can, take a strip of paper that is 4" × 9" (long enough to wrap around the can). Decorate the paper, then tape it around the can.

Not-So-French Horn

Materials

4 to 5 feet of hose piping

Funnel with an end that fits snugly into the hose pipe (A real funnel can be used or the top $\frac{3}{4}$ of a 2-liter drink bottle.)

Procedure

1. Attach one end of the tubing to the bottom of the funnel.

2. Curl the rubber tubing around your shoulder and hold the funnel end up.

3. Taking the end of the hose without the funnel, purse your lips tightly together. Blow through them so that they vibrate quickly, making the sound of a trumpet. This is the difficult part, but you should soon get the hang of it with practice. Be sure to blow hard and vibrate your lips as you do.

The longer the tubes on a real French horn, the lower the note. Horn players and buglers use the method of changing the shape of the mouth and blowing hard or soft to make different sounds.

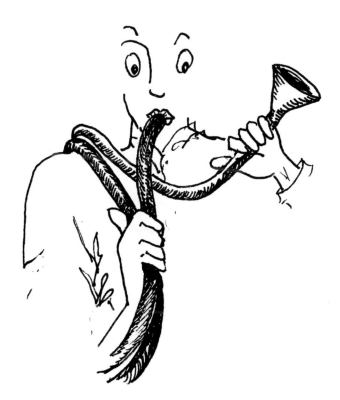

107 *Making Connections: Interdisciplinary Art Activities*

Shoebox Banjo

Materials

Shoe box

6 large rubber bands

Scissors

Glue

Optional: yardstick

Procedure

1. Cut a circular hole (approximately 4") in the lid of the box.

2. Fold the circle that you cut away to make a bridge for the strings as shown.

3. Glue the bridge to the box just above the hole.

4. Cut six slight grooves at both ends of the box. This will help hold the strings in place.

5. Stretch the rubber bands around the box, fitting them onto the grooves.

6. Pluck the bands to make a sound. The tighter the strings, the higher the sound. See how many different notes you can make.

7. If desired, add a yardstick for the "neck" of the banjo.

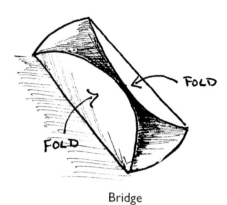

Bridge

Bridge

 Making Connections: Interdisciplinary Art Activities

Name _____ Date _____

Panpipes

Materials

7 wide drinking straws

2 pieces of wide packaging or masking tape, 4" long

Scissors

Procedure

1. Place the straws on one piece of the tape, $\frac{1}{2}$" apart.

2. Cover with the second piece of tape, pressing in between the straws so that the adhesive connects. Allow for the curved shape of the straws.

3. Tune the straws by cutting each one slightly shorter than the one before, creating an even line.

4. Blow gently across the top of each straw to produce a note.

The Greeks were one of the ancient cultures who used the panpipes for music. As Greek myth has it, the god Pan made these pipes when the nymph that he loved was changed into a reed.

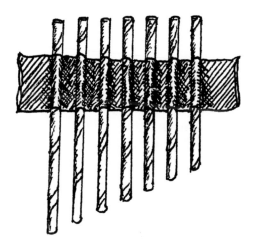

Maraca

A *maraca* is a percussion instrument used to create rhythm. The rattle is one of the oldest known musical instruments. Originally rattles were made from bean-filled gourds. The name and the instrument are usually associated with Latin music, but the African *shekere* (rattle) is a similar instrument.

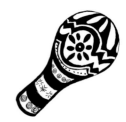

Materials

1 lightbulb (larger ones are easier to hold)

Wheat paste mixture

Bowl

Water

Newspaper or newsprint

Vegetable spray *or* petroleum jelly

Paint with brushes

Optional: sandpaper

Procedure

1. Cover the lightbulb with a thin layer of vegetable spray or petroleum jelly. This will help the newspaper not to stick to the lightbulb.

2. Following directions on the box, mix the wheat paste to the consistency of pudding.

3. Tear or cut $\frac{1}{2}$" to $\frac{1}{3}$" strips of paper. The smaller the strips, the smoother the surface.

4. Dip the paper into the paste mixture.

5. Wipe away any excess paste by pulling it through your fingers. Thick paste does not make the maraca stronger—it just makes it take longer to dry.

6. Cover the surface of the entire lightbulb with paper-paste strips, about four to six layers deep. This includes the metal base. Smooth the lumps and bubbles out as you go. The surface will dry just as you have made it, so the smoother the better.

7. When the maraca is completely dry, rap it sharply against the floor, wall, or table to break the bulb inside the paper covering. The broken glass on the inside will make the sound for the maraca when it is shaken. If a hole is punctured it can be mended with an additional strip of paper-paste mixture.

8. Sand with sandpaper for an extra smooth surface.

9. Paint.

South American Rain Stick

The rain stick originated in northern Chile. The Indians of this area used the rain stick in special ceremonies to produce rain. The sticks are made from the ocotillo cactus. The inside of the cactus is a web of dried tissue. Small pebbles are placed inside the dried cactus. As the pebbles are turned over in the tube, they catch on the maze in the inside to produce a musical rainlike sound.

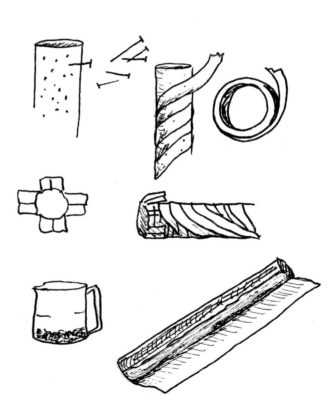

Materials

Empty wrapping paper tube

Masking tape

Adhesive shelf paper (wood grain if possible)

Flat-topped straight pins

Dried beans and peas of various sizes mixed with various plastic beads, wigglie eyes, and small nails.

Procedure

1. Push the straight pins into various places all over the cardboard tube. Try to have groups intersect and overlap so as to trap the beans as they fall. This makes the noise. Use at least 30 to 50 pins for best results.

2. Wrap the entire tube with masking tape.

3. Cover the middle part of a 3" × 3" piece of tape so the sticky side is not exposed. (If the tape is sticky inside the tube, the beans will stick to it.) Place this on one end of the pinned tube.

4. Wrap with tape to secure.

5. Pour $\frac{1}{4}$ cup of beans into the tube. Test by holding a hand over the open end and inverting. If the beans come down too fast, you need more pins.

6. Seal the open end as in steps 3 and 4.

7. Wrap with the shelf paper and decorate.

111 *Making Connections: Interdisciplinary Art Activities*

Share Your Bright Ideas with Us!

We want to hear from you! Your valuable comments and suggestions will help us meet your current and future classroom needs.

Your name_____Date_____

School name_____Phone_____

School address_____

Grade level taught_____Subject area(s) taught_____Average class size_____

Where did you purchase this publication?_____

Was your salesperson knowledgeable about this product? Yes_____ No_____

What monies were used to purchase this product?

___School supplemental budget ___Federal/state funding ___Personal

Please "grade" this Walch publication according to the following criteria:

Quality of service you received when purchasing ..A B C D F
Ease of use..A B C D F
Quality of content..A B C D F
Page layout ...A B C D F
Organization of material ...A B C D F
Suitability for grade level ...A B C D F
Instructional value...A B C D F

COMMENTS:_____

What specific supplemental materials would help you meet your current—or future—instructional needs?

Have you used other Walch publications? If so, which ones?_____

May we use your comments in upcoming communications? ___Yes ___No

Please **FAX** this completed form to **207-772-3105**, or mail it to:

Product Development, J.Weston Walch, Publisher, P.O. Box 658, Portland, ME 04104-0658

We will send you a **FREE GIFT** as our way of thanking you for your feedback. **THANK YOU!**